# Watercolor Basics: Perspective Secrets

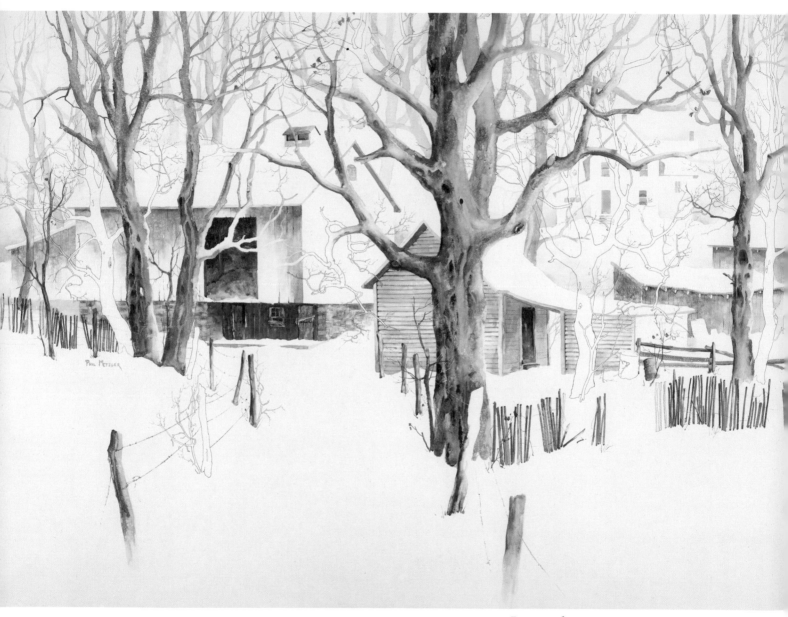

*Farmyard*
36″×52″ (91cm×132cm)
watercolor plus pencil on
illustration board

# Watercolor Basics: Perspective Secrets

## PHIL METZGER

**NORTH LIGHT BOOKS**
CINCINNATI, OHIO

*Tangle*
24″×30″
(61cm×76cm)
watercolor on
illustration board

Other fine North Light Books are available from your local bookstore, art supply store or direct from the publisher.

06   05   04   03        10   9   8   7

**Library of Congress Cataloging-in-Publication Data**

Metzger, Philip W.
    Watercolor basics: perspective secrets / by Phil Metzger.—1st ed.
        p.      cm.
    Includes bibliographical references and index.
    ISBN 0-89134-880-8 (pbk. : alk. paper)
    1. Watercolor painting—Technique. 2. Perspective. I. Title.
ND2420.M48   1999
751.42′2—dc21                                               98-38014
                                                           CIP

Edited by Glenn L. Marcum
Production edited by Bob Beckstead

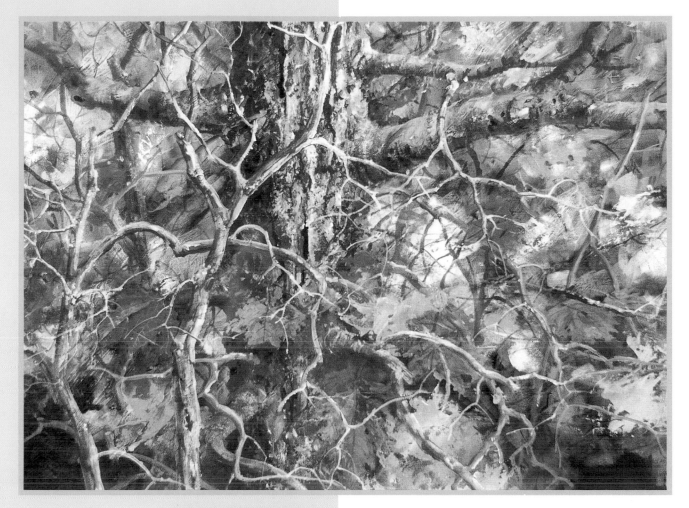

## ABOUT THE AUTHOR

Without benefit of formal art training, Phil Metzger left a fifteen-year career in computer programming and management to become a painter. For twenty years he has exhibited his paintings in national and regional shows and has sold his work occasionally through galleries, but mostly at street art fairs. During that time he developed a parallel interest in writing. Having made a number of firm decisions to do one or the other—paint or write—he has now made a firm decision to do both.

Metzger's books include *Perspective Without Pain* (North Light, 1992), *Enliven Your Paintings With Light* (North Light, 1994), *The North Light Artist's Guide to Materials & Techniques* (North Light, 1996) and *Realistic Collage Step by Step* (North Light, 1998), which he co-authored with Michael David Brown. He has also written articles on drawing for *The Artist's Magazine* and *Arts and Activities* magazine.

# DEDICATION

*To my good buddies
Michael and Morris and Fred and Shirley*

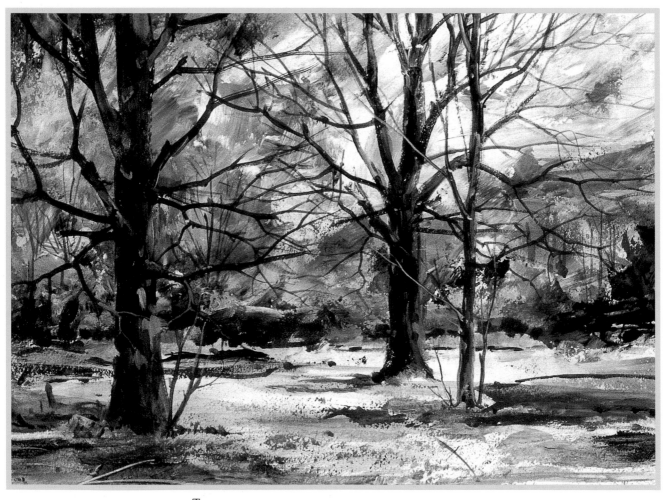

*Trees*
20″×22″ (51cm×56cm)
watercolor on
illustration board

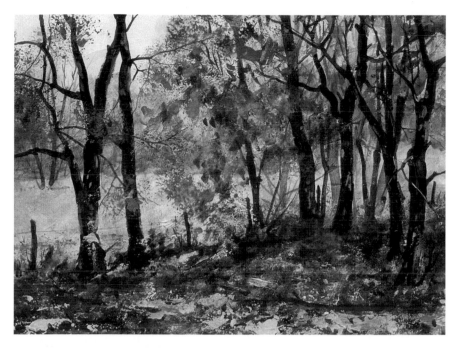

*The Clearing*
20" × 22"
(51cm × 56cm)
watercolor on
cold-press paper

## ACKNOWLEDGMENTS

Writing for a living is only a little less daunting than painting for a living. A writer needs encouragement (It's okay, Phil—somebody will buy it) and advice (Phil, why not be a plumber?). I get all that from four wonderful children, Lineman Scott, Mother Lori, Counselor Cindy and Doctor Jeff. And I get it from good friends like Morris Waxler, who (by cheating) regularly trounces me in racquetball; Michael Brown, a gifted artist who has taught me a lot about art and business and being upbeat; Fred Kaplan, local camera expert and jokemeister, who gave me help when I needed it; and Shirley Porter, who locks me in my office and won't let me out until I've written the day's ration of words.

Then there are editors. I've read lots of books and articles about the writing profession and they all warn about editors. Grumpy editors. Crazy editors. Obnoxious editors. Well, you can forget all that. At North Light, I've never met an editor who fits those sour descriptions. Working with the people at North Light has always been a pleasure. Right off the bat you deal with acquisitions editor Rachel Wolf who is approachable, friendly, professional and always prompt in replying to a proposal for a new book. Unlike a lot of editors in the book business, she actually answers letters and phone calls—and not six months later, either! Then there's Glenn Marcum, this book's content editor who saw to it that the book hung together and made sense and then got it ready for copyediting and production. I've only met Glenn over the telephone, but he is bright and upbeat and obliging and helpful. It did, however, take me a little while to get him to stop calling me Sir!

Glenn turned the manuscript over for copyediting to Anne Slater, who did a perfect job, and then to production editor Bob Beckstead. Bob was production editor on one of my earlier books, so I knew what I was getting—an experienced editor who knows his business and knows how to work with an author to make things go smoothly.

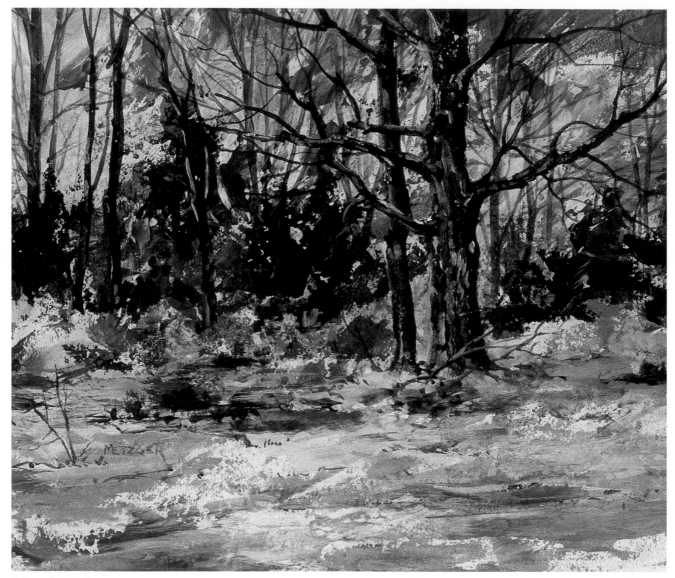

*Edge of Woods*
20″ × 22″ (51cm × 56cm)
watercolor and acrylic on illustration board

# CONTENTS

This watercolor makes use of many of the perspective techniques described in this book. The eye is drawn into the distance by diminishing tree sizes, aerial perspective, value changes and varying treatment of edges and details.

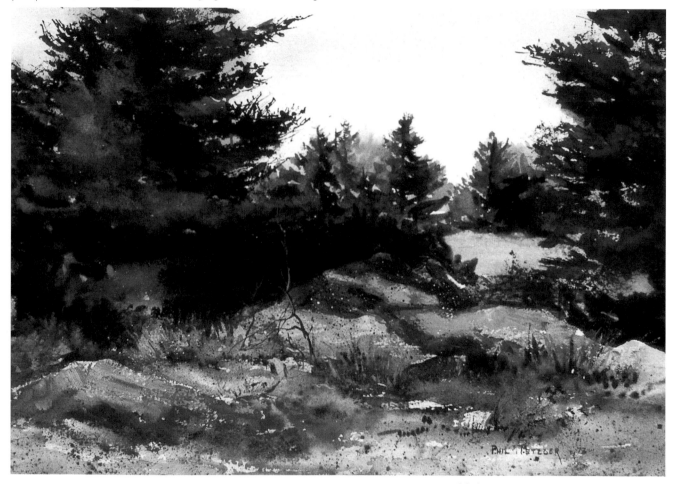

*Maine*
11″×15″ (27.9cm×38.1cm)
watercolor on Arches 140-lb
cold-press paper
Collection of Jerry and Jan Taylor,
Chevy Chase, Maryland

## PREFACE

Artists have been using the principles of perspective for centuries. The principles are simple but, unfortunately, they're sometimes made complicated by overly pedantic treatments. In this book we stick to the practical. Whether you're just getting started in drawing and painting or are well along in your career, you'll find the ideas here easy to grasp and you'll also discover they can have a huge impact on your art.

Although each chapter discusses separate perspective techniques, you almost never use only a single technique—the various techniques work together to help create the illusion of depth.

Along the way you'll find a number of sidebars that define important terms. Other sidebars offer notes telling you what colors were used for the accompanying painting or sketch, in case you're interested in trying to duplicate what you see.

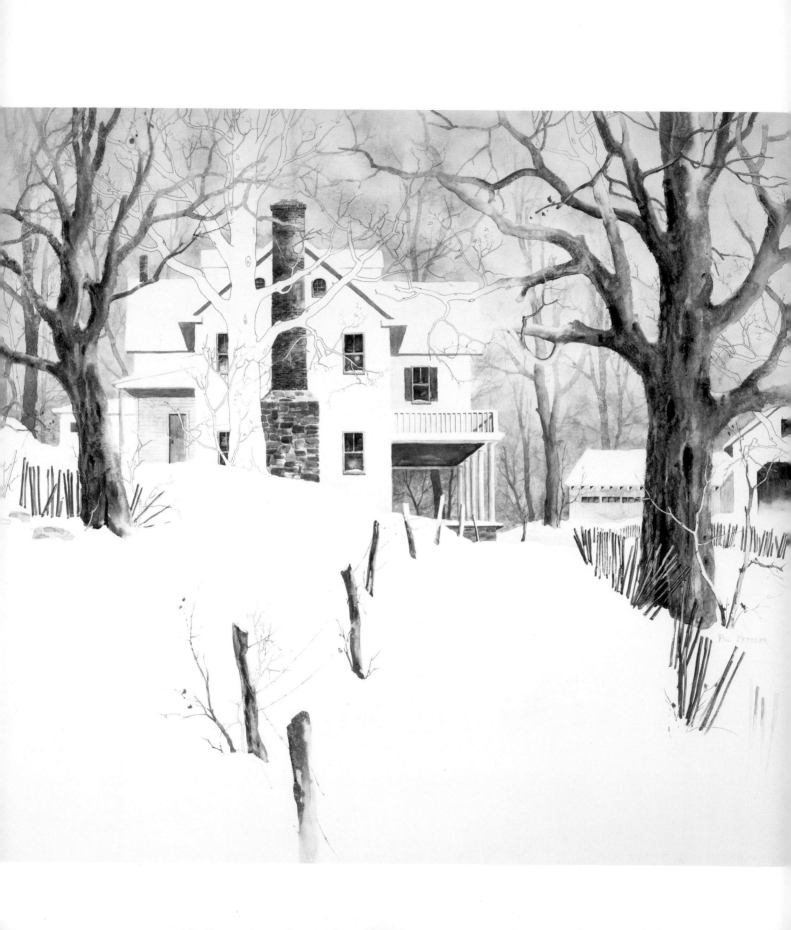

INTRODUCTION:
# WHAT DOES PERSPECTIVE REALLY MEAN?

When people hear "perspective" they go hide in a closet! They think perspective means drawing a zillion construction lines, using geometry, trigonometry and advanced physics. Phooey! Learning perspective is no more complicated than learning to mix colors. It's certainly less complicated than learning to draw.

*The White House*
40″ × 60″ (101.6cm × 152.4cm)
watercolor and inkline on
Crescent illustration board

# Perspective Defined

Here's how the dictionary defines perspective: The science of painting and drawing so that objects represented have apparent depth and distance. To put it another way, perspective is what makes a two-dimensional picture seem three-dimensional.

Artists who draw and paint realistic pictures are always looking for ways to give their pictures more depth, more sense of realism. You can use lots of techniques, or tricks, to fool the eye and we'll explore many of them in the chapters that follow. Here's a preview:
- aerial perspective
- size and space variations
- overlap, detail and edges
- shadows
- one-point linear perspective
- two-point linear perspective
- curves in perspective

## *Aerial Perspective*

This is what causes distant objects to look paler and cooler than nearby objects. It's what makes a faraway mountain look blue when you know darn well it's no such color.

**Color Notes**
Middle mountain: Cobalt Blue
Farthest mountain: Phthalocyanine Blue
Nearest mountain: Ultramarine Blue plus
    Burnt Sienna

distant mountain
looks bluish
(but it isn't)

nearest hills are
warmer and darker
than distant ones

## Size and Space Variations

If you have a row of same-sized objects or equally spaced objects, such as fence posts, you can create a feeling of distance if you make them progressively smaller and closer together as they march off into the distance.

**Color Notes**
Ground: Phthalocyanine Green, Burnt Umber
Sky: Phthalocyanine Blue
Posts: Ultramarine Blue and Burnt Sienna

here the posts are the same height
and they're spaced uniformly, so this picture looks flat . . .

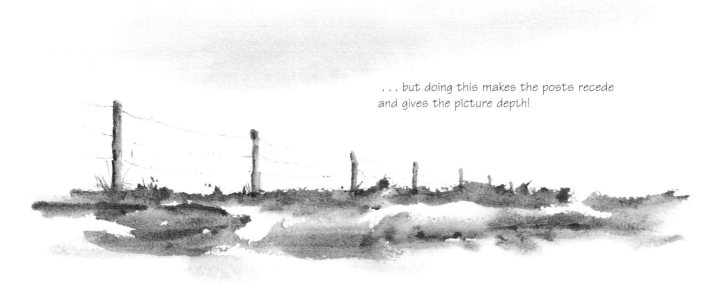

. . . but doing this makes the posts recede
and gives the picture depth!

## Overlap, Detail and Edges

You can make objects seem to advance or recede by placing closer ones in front of distant ones and by giving near objects more detail and sharper edges.

**Color Notes**
Distant mountain: Phthalocyanine Blue
Everything else: Ultramarine Blue, Burnt Sienna, Phthalocyanine Blue

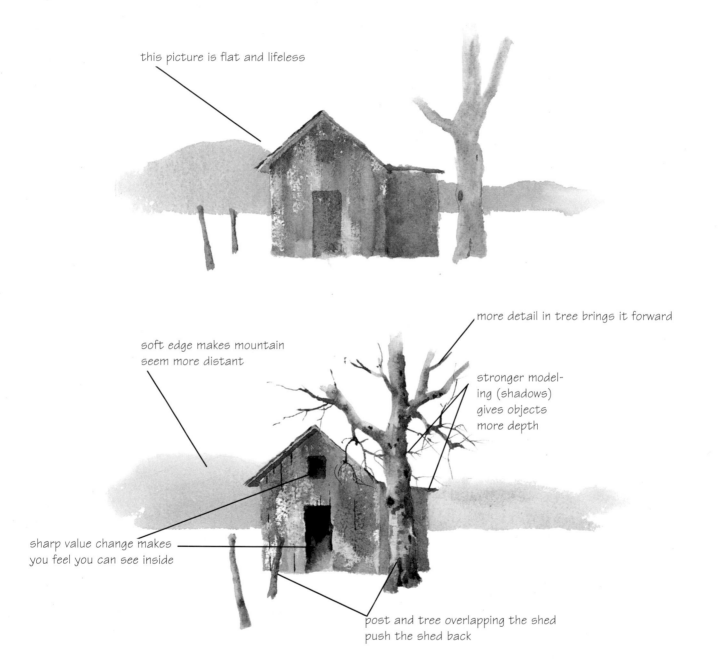

this picture is flat and lifeless

soft edge makes mountain seem more distant

more detail in tree brings it forward

stronger model-ing (shadows) gives objects more depth

sharp value change makes you feel you can see inside

post and tree overlapping the shed push the shed back

## Shadows

By introducing deep shadows you can suggest depth. For example, in the sketch of the shed, just making the doorway dark helps establish depth by making you feel you're looking inside the shed. By modeling an object—that is, shading some of its surfaces—you can make even a small object seem three-dimensional. Shading on the side of the tree away from the sun makes the tree feel rounded, as though it actually has thickness.

## One-Point Linear Perspective

Parallel lines, such as the sides of the straight road in this picture, seem to meet at a single point in the distance on the horizon. This is an example of one-point linear perspective.

**Color Notes**
Green areas: Phthalocyanine Green, Raw Umber
Sky: Phthalocyanine Blue
Road: Ultramarine Blue, Raw Umber

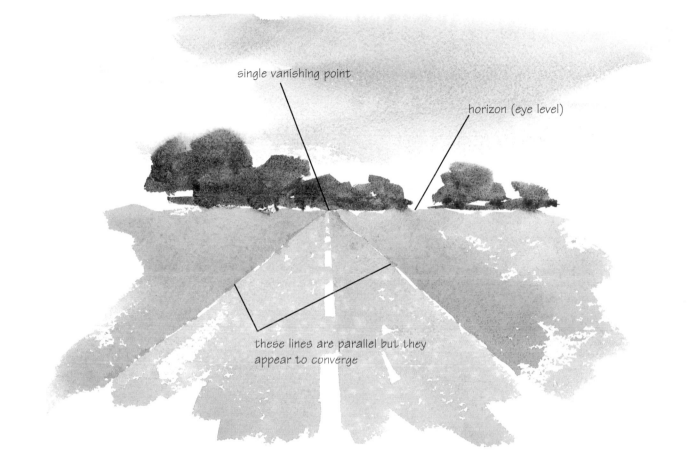

single vanishing point

horizon (eye level)

these lines are parallel but they appear to converge

## Two-Point Linear Perspective

When a rectangular object, such as this box, is turned so you see two of its sides, its parallel edges (if you imagine extending them far enough) meet at a pair of vanishing points on the horizon. This is an example of two-point linear perspective.

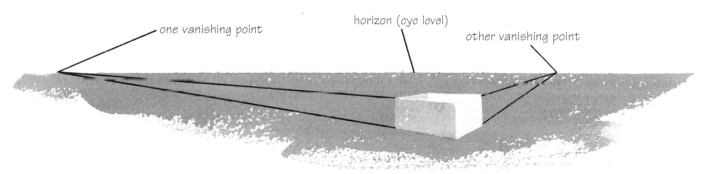

one vanishing point

horizon (eye level)

other vanishing point

## Curves in Perspective

Circular objects only appear circular when you look at them straight on. If you tilt them at any angle they still look curved, but not circular—they look like ellipses. Hold an empty dish or cup in front of you and see how its circular outline changes to a flatter and flatter ellipse as you gradually tilt the object.

**Color Notes**
Coffee: Burnt Umber
Cup: Phthalocyanine Blue
Background: Ultramarine Blue and Burnt Umber

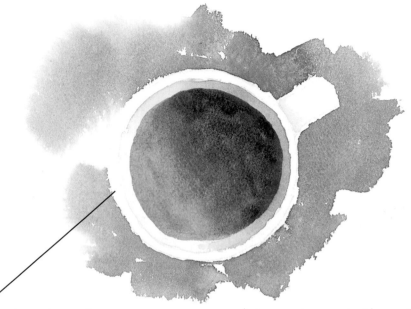

if you look at this mug from above, it's circular . . .

. . . but seen at an angle, it's an ellipse!

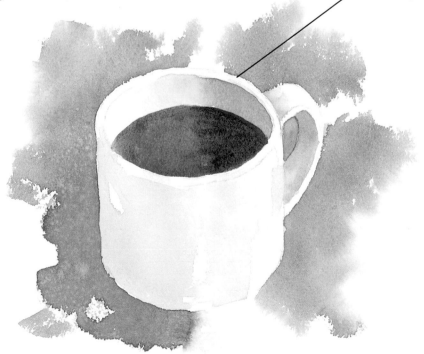

# A Second Look

Let's look at *The White House* again. This combination painting and drawing illustrates many of the perspective techniques described in upcoming chapters: linear perspective, overlap, size variation, detail, value change, modeling, edge change and aerial perspective. Because I like playing with flat, white shapes I chose not to model the white areas.

*The White House*
40″ × 60″ (101.6cm × 152.4cm)
watercolor and inkline on Crescent illustration board

**Color Notes**
Sky: Burnt Sienna, Phthalocyanine Blue, Ultramarine Blue
Windows and doorways: Alizarin Crimson, Burnt Sienna, Burnt Umber, Ultramarine Blue, Yellow Ochre
Trees and posts: Burnt Sienna, Ultramarine Blue
Chimneys: Alizarin Crimson, Burnt Sienna, Cadmium Red, Ultramarine Blue

## AERIAL PERSPECTIVE:
# PUTTING AIR
# IN YOUR PAINTING

We know distance affects the colors we see. An object you know is bright red looks dull red or even gray when you see it at a distance. A hill you know is covered with fall color looks, at a distance, blue. The reason is this: As light travels from an object to your eye it passes through a layer of air that contains impurities, such as water droplets, dust and soot. This unclear layer of air lessens the *amount* of light getting through (thus making objects look grayer and usually lighter in value) and it affects the *colors* that get through (warm colors such as reds are inhibited while cool colors such as blue pass through easily).

The dulling effects of an air layer on color and value are commonly called aerial perspective (or sometimes atmospheric perspective). By simulating aerial perspective in your paintings, you can dramatically increase the illusion of distance, as in the mountain sketch in chapter one.

*Big Meadow*
30″ × 40″ (76.2cm × 101.6cm)
watercolor on illustration board
Collection of Scott Metzger

# Using Color to Create Depth

As we've seen, distant objects tend to look cooler in color than those same objects appear up close. Landscape artists make use of this phenomenon by placing warmer colors in the foreground of a painting and cooler ones in the background. You can see from the hills illustration how effective this can be. We simply build our paintings to conform to the way we see things. The general rule of thumb is: Warm colors advance; cool colors recede.

**Color Notes**
Blue hills: Phthalocyanine Blue, Raw Umber
Green hills and trees: Phthalocyanine Green, Raw Umber

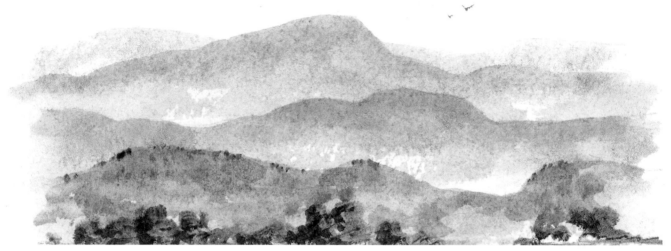

In this scene the distant hills are painted in what might be their actual colors and there is little sense of distance except for some value change and the use of more detail in the closer hills.

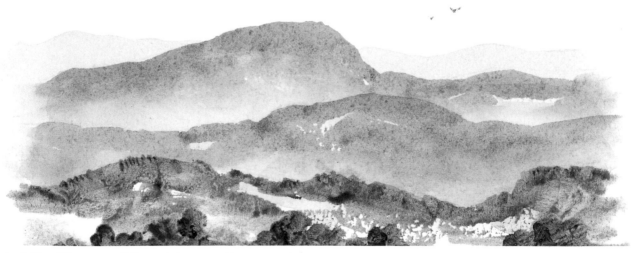

Look at the difference a little aerial perspective can make! Those distant hills still look green to someone standing on them, but not to an observer far away.

## Making Warm Colors Recede

Obviously, not every warm-colored object will appear in the foreground of your painting. You may well want to place a red barn, for example, in the distance. How do you put such an object in the painting without having it seem to jump forward because of its warm color? You simply mute the color enough to make it feel right. If your red barn is in the foreground, make it as red as you wish; if it's in the middle ground, dull the red a bit; and if it's to be far away, dull the red even more. It's entirely possible for a bright red barn to appear grayish red if it's far enough away and the air is hazy.

**Color Notes**
Biggest barn: Cadmium Red Deep
Phthalocyanine Green added for other barns

To make an object such as this red barn appear more distant in your painting, dull its red color. The farther back you want it to be, the duller you should make the red. You can dull a color either by adding black or gray to it or, as here, by adding some of the color's complement—in this case, green.

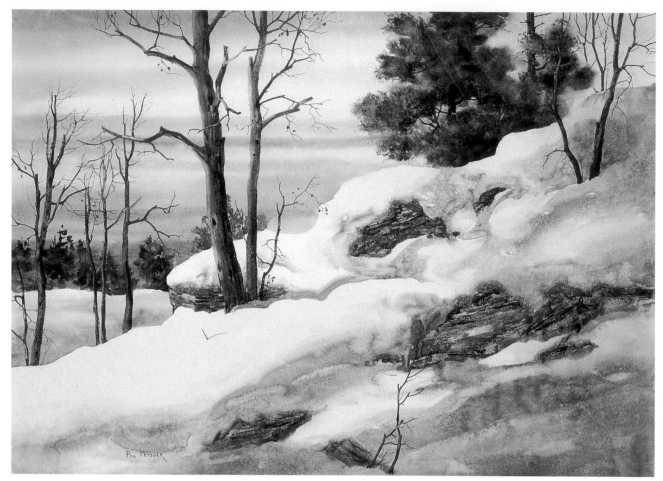

In this painting the warm color is in the distance and the cool is forward! When we reverse the usual order of things like this, we must rely on other perspective techniques to give us depth—for example, the use of more detail and sharper edges up close.

*Snowscape*
22″ × 30″ (55.9cm × 76.2cm)
watercolor on illustration board

# About Those "Rules"

The rule that "warm colors advance, cool colors recede" is useful and generally works well in a painting, but there are exceptions galore. In painting there are no inviolable rules. There are rules of thumb, suggestions, tips, advice—but that's it! You're on your own and you're at liberty to do whatever you please to produce a painting that satisfies you.

**Color Notes**
Sky: Cadmium Orange, Phthalocyanine Green, Phthalocyanine Blue, Raw Sienna, Ultramarine Blue
Snow: Phthalocyanine Blue, Ultramarine Blue
Trees: Burnt Umber, Burnt Sienna, Phthalocyanine Green, Raw Sienna, Raw Umber, Ultramarine Blue
Rocks: Burnt Umber, Burnt Sienna, Pthalocyanine Green, Pthalocyanine Blue, Raw Umber, Ultramarine Blue

# The Color Wheel

To use color to suggest how far away an object is, it's important to understand color basics. Here is a simple color wheel showing the primary colors (red, blue and yellow) and the secondary colors (orange, purple and green). You get a secondary color by mixing two primaries. Colors directly opposite one another on the color wheel are called complementary colors—red and green are complements, as are yellow and purple and blue and orange.

You can get a variety of grays by mixing any two complementary colors, such as red and green. But it makes a big difference which red and which green you use. Alizarin Crimson and Phthalocyanine Green, for example, give you one set of grays, while Cadmium Red and Phthalocyanine Green produce much different grays.

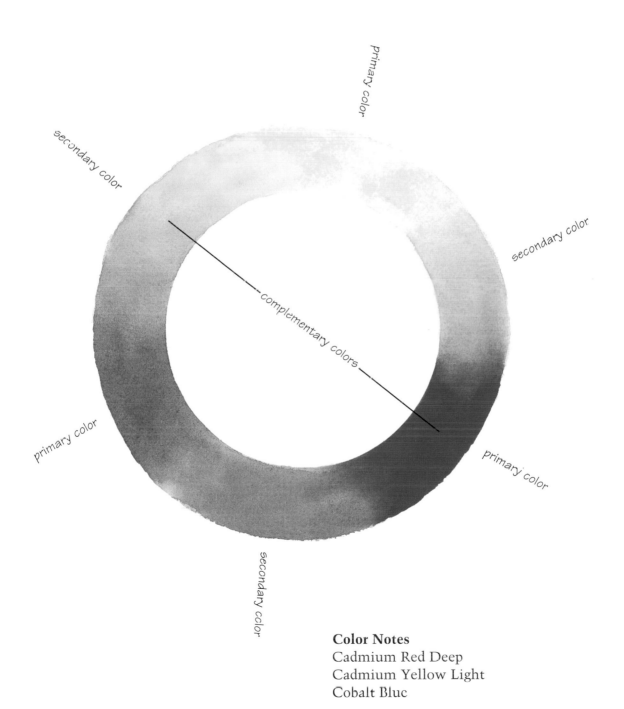

primary color

secondary color

secondary color

complementary colors

primary color

primary color

secondary color

**Color Notes**
Cadmium Red Deep
Cadmium Yellow Light
Cobalt Blue

# Woods Perspective

Woodland scenes are a popular motif in watercolor. You can use a number of techniques, including aerial perspective, to suggest depth in the woods. Along with aerial perspective, use softer edges for the more distant trees and more detail in the forward trees.

To introduce aerial perspective into a scene, think in terms of three stages: distant, middle ground and foreground. It's the way stage designers think when making stage props to simulate distance—at the rear of the stage is a light, fuzzy prop with little detail; halfway toward the front of the stage are props with more detail; and in the front are the strongest, most detailed props.

**Color Notes**
Step 1: Phthalocyanine Blue and Cobalt Blue
Step 2: Phthalocyanine Blue, Cobalt Blue and
    Burnt Sienna
Near trees: Ultramarine Blue and Burnt Sienna
Shadows: Cobalt Blue, Phthalocyanine Blue

It's helpful to build your picture in three steps. The first step is in the distance and it's light in value and cool in color. The second is darker and warmer and the third is still darker and warmer.

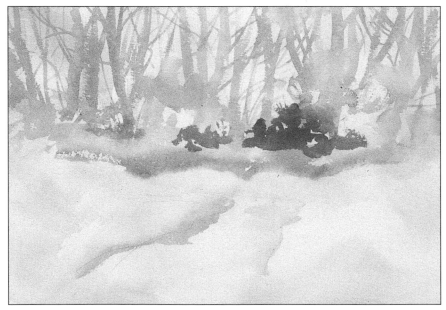

Step 1: Paint distant trees without much detail, keeping the color cool and the value light.

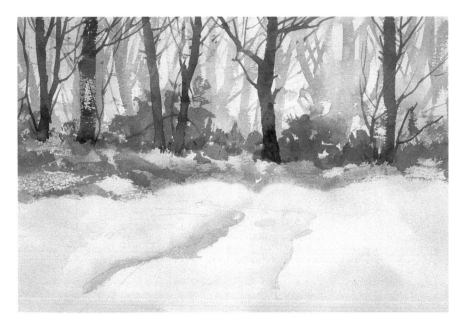

Step 2: Now paint a middle-distance set of trees, darker and warmer. Begin to show more detail. You can paint right over the light background trees. Don't be afraid to "lose" some of those first trees by covering them with these darker ones.

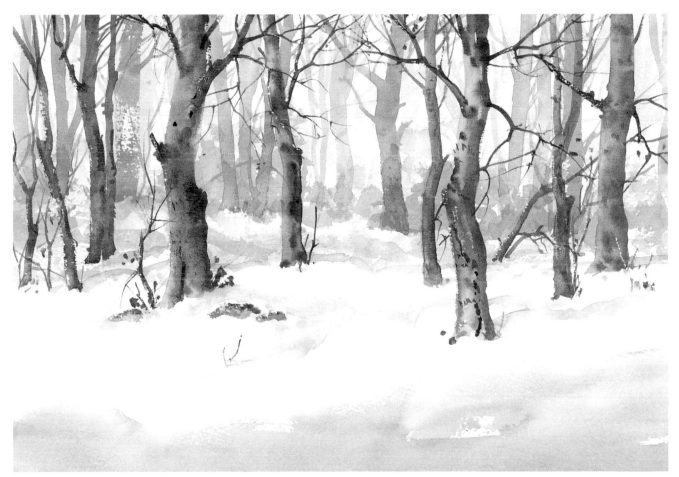

Step 3: Now you paint the fun things—the nearer, more detailed trees along with their cast shadows. Again, some of these trees will partially cover those you've already painted—that's just the way woods will look. Keep in mind your light source and paint shadows accordingly. Here the light is from the left, so shadows go right and the right sides of the trees are darker than the left.

Remember, you don't need to do the three layers in a slavish manner. You can go back, as I did, and add things to the early layers even after you've finished the final one.

# City Perspective

You don't have to be in the mountains to notice aerial perspective. City people know hazy air or fog can dramatically change how their city looks. Sometimes haze is so dense, because of the pollutants from automobiles and factories, that buildings only a short distance away are blurry, if not invisible. These effects, of course, may be magnified at night when your vision is affected by failing light as well as haze.

## Stretching Your Paper

Here's how you can stretch your watercolor paper to keep it lying flat as you paint. First, soak the paper in clean water for a minute or two (a little longer if you're using paper heavier than 140-lb. [300 gsm]).

Pour off excess water. Clamp or tack or staple or tape the paper to your board and either let it dry (you can hasten drying with a hair dryer) or use soft, clean white paper towels to gently rub the surface dry. If you plan on painting wet-in-wet, don't dry the paper—just go ahead and paint into the wet surface.

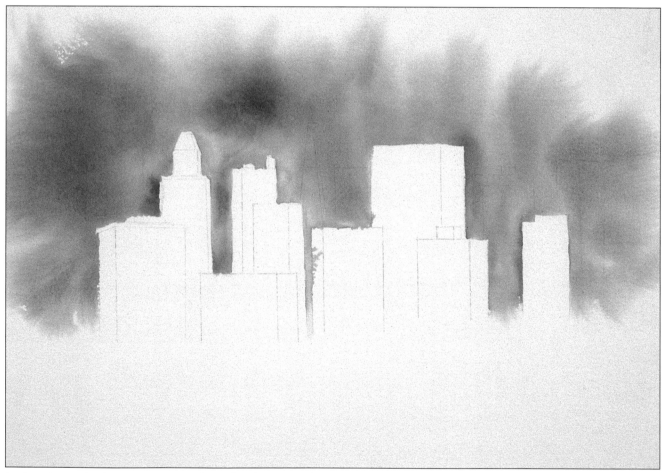

Let's paint a simple city scene on a hazy day. In watercolor it's easy to paint such effects. After lightly sketching in your drawing and stretching your paper, dampen the paper's surface with clean water and let the surface water evaporate until the surface is just damp, not oozy wet. With a large brush, lay in a light gray background all over the paper, darker at the top. Clamp or tape the paper in place and dry it.

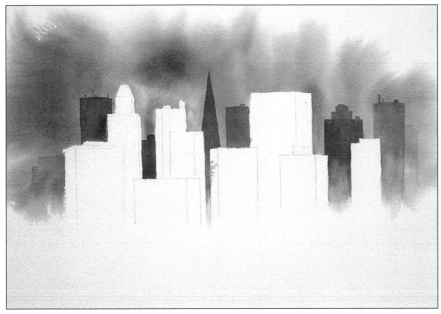

Now paint some nearer buildings. Use warmer-colored paint but be careful not to paint too much detail so the buildings remain distant. Get the feeling of ground fog by wetting the bottom portion of the painting and then painting the buildings down into the wet so they blur and fade.

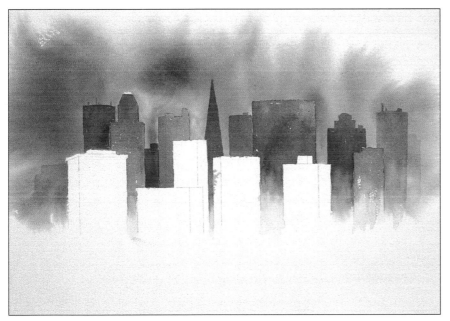

On the dry paper paint some distant shapes, bluish-gray and without detail.

Finally, paint the nearest buildings warmer still in color and add enough detail to make them feel closer than the earlier buildings. Again, run these buildings into wet paper at the bottom of the picture to get them to fade into the ground fog. If the nearest buildings don't happen to be red brick, you can still make them advance by making them sharper and more detailed than distant ones. If you decide at the end that you wish you had made the sky darker (as I did), carefully dampen the sky area with clear water and paint a darker gray into the wet.

**Color Notes**
Cadmium Red Deep
Phthalocyanine Blue, Brown Madder Alizarin, Burnt Umber (Combining these three colors in the right proportions gives you a beautiful range of grays)
Yellow Ochre

# A Second Look

Let's review *Big Meadow* from the beginning of the chapter. Aerial perspective is evident here as the picture progresses from faint blue in the distance to warmer greens in the middle distance to the warm browns and reds of the meadow up close. In this picture I used opaque acrylic paint to help get the foreground textures.

*Big Meadow*
30" × 40" (76.2cm × 101.6cm)
watercolor on illustration board
Collection of Scott Metzger

## Tips

- Paint what you see, not what you know. For instance, you may know a distant hill is covered with orange fall colors, but paint it the way it looks from a distance, which will be cooler than orange.
- Don't be afraid to stretch the truth to make your painting believable. For example, if the day is clear and visibility is so sharp you can see distant objects clearly, make them less clear for the sake of the picture.
- When you paint in stages (rear, middle, front) try dabs of the colors to see if they work well together. Sometimes we tend not to make the stages different enough.

- Try painting your first stage wet-in-wet to make it seem even more distant.
- If there are dark elements in the distance (or light elements in the foreground) that's perfectly okay as long as the overall progression is from pale in the distance to stronger in the foreground. One common example of a distant dark is a shadow cast by a cloud over some pale, distant hills.
- Remember, no rules are sacrosanct. They're only there to get you started. In the end, all that counts is the success of your picture.

# 3

## SIZE AND SPACE VARIATIONS:
# LEADING THE WAY INTO YOUR PICTURE

Y ou can introduce a lot of depth in a picture by showing objects getting smaller as they march off into the distance. It doesn't matter that in reality the objects are all the same size—if some are farther away, they look smaller. That's the way our eyes and brains interpret things. The lesson in this is that you should paint what you see (objects apparently smaller in the distance) rather than what you know (objects are really all the same size).

*Trees and Fenceline*
30″ × 40″ (76.2cm × 101.6cm)
watercolor and pencil
on illustration board

# Changes in Size and Space

Here's a row of battered beer cans all the same size. Because the one in the rear is shown smaller than the one in front, we know the one in the rear is farthest away.

It's not only the diminishing sizes of objects that make them seem distant—the spaces between them behave in the same way. Power poles along a country road are generally spaced evenly, but if you're looking at them at an angle, not only do the poles shrink in height, but the spaces between them get smaller.

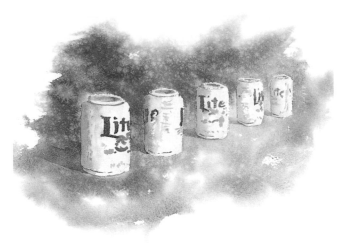

boring symmetry, no depth

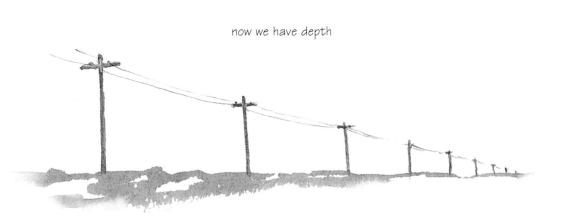

now we have depth

## Varied Spacing

This fence obeys the rules, but instead of aiming for a bull's-eye on the horizon it takes some detours. One section recedes in an orderly way; another section runs parallel to the picture surface (so the posts there are the same size and evenly spaced), and another becomes a jumble as posts seem to crisscross one another as they disappear over a hill.

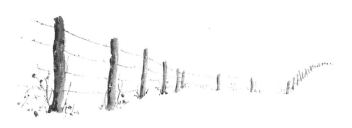

## A Common Mistake

Probably the most common mistake we make in using size and space variation is overdoing it. It's easy to go overboard, resulting in a stiff, unimaginative picture. The first example shows a row of trees behaving too properly.

Maybe the trees you're looking at as you paint are nice and orderly, but your picture will look better if you mess things up a bit. Vary the spacing a little, as in our second example; change the tree heights and alter the lollipop shapes.

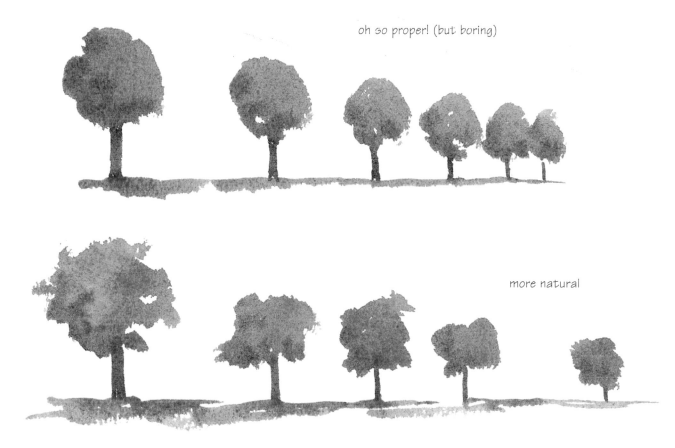

oh so proper! (but boring)

more natural

# Clouds

Unlike fence posts, clouds come in an infinite number of sizes and shapes, but one way to force depth in a landscape painting is to make clouds obey the same rules as receding fence posts. Make them larger up close and smaller in the distance. Although clouds sometimes do appear this way, of course, they're not always so obliging. This is a technique to use occasionally, but don't overdo it.

### Mixing Perspective Techniques

You'll find you rarely use one perspective technique by itself—usually you use some combination of techniques. For example, the cloud painting employs aerial perspective, overlap and modeling in addition to size and space variation.

### Color Notes

Clouds: Burnt Sienna, Ultramarine Blue
Sky: Phthalocyanine Green, Phthalocyanine Blue
Trees: Burnt Sienna, Burnt Umber, Ultramarine Blue
Hills, snow: Cobalt Blue, Phthalocyanine Green, Phthalocyanine Blue, Ultramarine Blue

*Cloud Study*
11" × 15" (27.9cm × 38.1cm)
watercolor on Arches 140-lb. (300gsm) cold-press paper
Collection of Cindy and Rick Fazendin

# Estimating Sizes

When you draw a scene you make decisions about the sizes of things. Often you divide your picture surface into a few main elements, such as sky, hills and foreground. Then you choose a main object, such as a building, and sketch in its boundaries. From that point on (if you're painting a realistic picture) you make the sizes of all other objects relative to the size of that first object. You say the building is so high and the tree is half again as high and the fence is about half the height of the building's doorway, and so on.

Keep this in mind: It makes no difference what the *actual* sizes of objects are—what counts is how the sizes *appear* from wherever you're sitting or standing. A fence, for example, may be actually half as high as a shed, but because the fence is close to you and the shed farther away, the fence may easily seem higher than the shed—and that's the way you should paint it. Flip back to the opening painting in chapter one, *The White House*, to see what I mean. The fence posts in the foreground are more than half the height of the house! Yet it seems right, doesn't it, because that's how we see things.

Here is a simple way to "size up" an object. Suppose you're looking at a scene with three main elements: a barn, a silo and a tree:

## Barn

If the barn is your center of interest, start with it. Decide where to place it in your picture and mark off its outer dimensions. You can make the barn whatever size you wish on your paper but the silo and tree must be sized relative to the size of the barn.

*Silo: Step 1*   Now let's size the silo. You can see it's higher than the barn, but how much higher? Hold a pencil (or brush or stick) at arm's length, close one eye, and line up the top of the pencil with the top of the barn. Then slide your thumb down the pencil until your thumbnail marks the bottom of the barn. The pencil from thumbnail to tip represents the height of the barn.

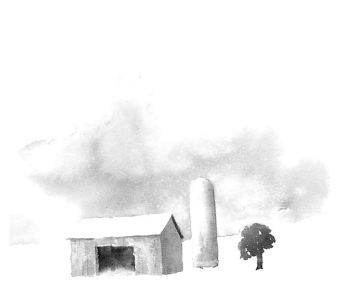

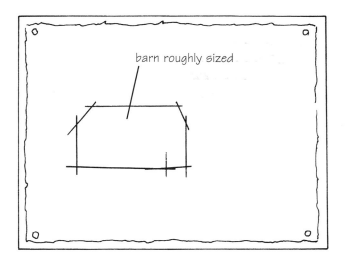

barn roughly sized

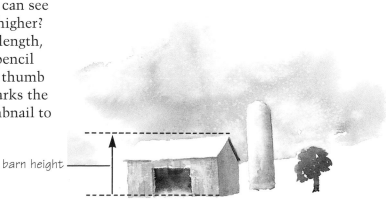

barn height

*Silo: Step 2*  Keeping your arm extended and your thumb in place, shift the pencil to the silo. See about how many times the pencil (from thumbnail to tip) fits within the height of the silo. Looks like the silo is about half again as high as the barn. Mark off on your picture a height that's half again as high as the barn you've already sketched.

## Tree

Now you have the sizes of the barn and the silo relatively correct on your paper. Do the same thing to size the tree, comparing it to either the barn or the silo. The tree seems to be about half the height of the silo.

It's easy to apply the same measuring method to whatever you're looking at. Use it to measure the height and width of the barn door and the height of the roof. Use it also to measure the spaces between the barn, silo and tree. In other situations, size up windows, chimneys, hills, animals—all sorts of things. In a still life you might compare the height of a glass with the height of a decanter.

## Width

Vertical measurements are not the only kind you can make. Turn your hand so the pencil or ruler is horizontal and you find out the widths of things. Compare the width of one object with that of another or compare the width of an object to its height. For instance, in the example above you'll find the width of the silo is about one-fourth the width of the barn and the barn is about twice as wide as it is high.

You can use the same estimating process to figure out the relative spacing between objects. Spaces have lengths just as objects do. In fact, use the method to compare the size of anything to anything. You may be uneasy about measuring things without using inches or feet or centimeters. You can get more accurate by using a ruler. If the barn is two inches high on the ruler and the silo is three inches high, then you know to make the silo on your paper half again as high as your barn. All you're looking for when you sight along the pencil or ruler or brush or stick is relative size. You can draw the objects whatever size you wish on your paper—the barn may be a foot high and that would make the silo a foot-and-a-half high.

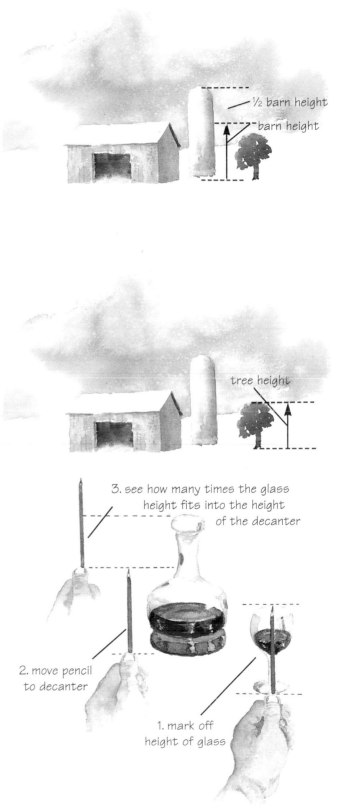

½ barn height

barn height

tree height

3. see how many times the glass height fits into the height of the decanter

2. move pencil to decanter

1. mark off height of glass

## Those Pesky Slanted Lines

You can use your trusty pencil to estimate not only sizes of things, but the slant of lines as well. In the barn example, the top roof line dips slightly downward toward the left. To get the roof line, draw it lightly on your paper, then check its slant using the pencil-and-squint method. Hold your pencil at arm's length and rotate your wrist till the pencil is at the same angle as the roof line. Move the pencil to your paper or canvas, arm still extended, without changing the slant of the pencil. Lay the pencil against your drawing and its slant should approximate the slant of the roof line.

There will be much more about slanting lines in later chapters.

pickets

drawers

railroad ties

windows

bricks

Potpourri: some examples of the use of size and space variations

# A Second Look

Take another glance at *Trees and Fenceline* and you'll see that both the trees and the fence posts diminish in size as they recede. In addition, values lighten in the distance as discussed in the chapter on aerial perspective.

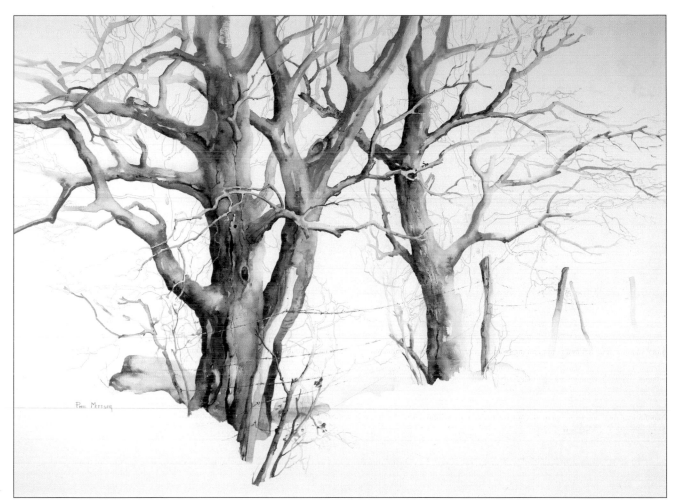

*Trees and Fenceline*
30" × 40" (76.2cm × 101.6cm)
watercolor and pencil on illustration board

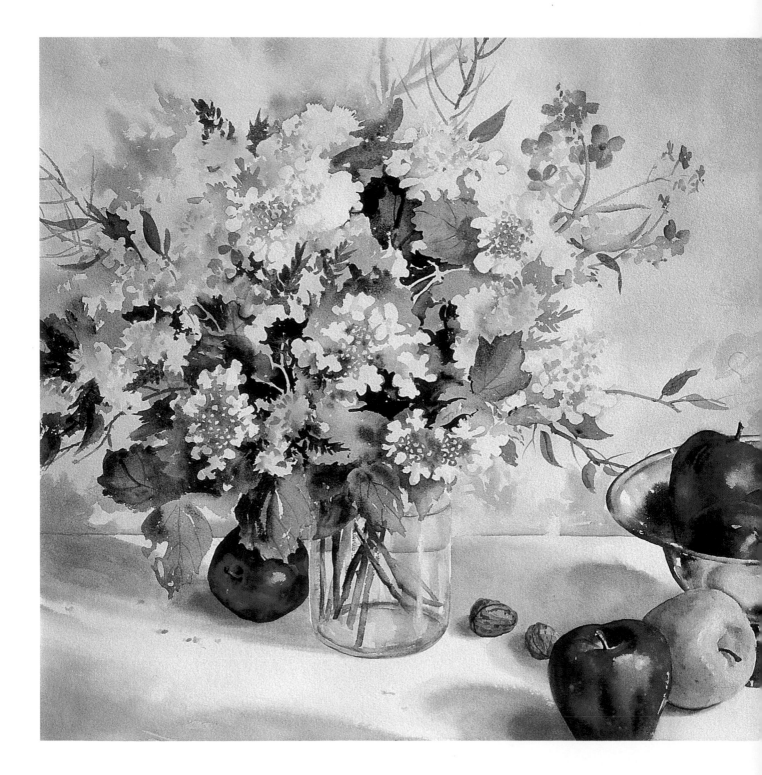

## 4

OVERLAP, DETAIL, EDGES:
# SEPARATING BACKGROUND FROM FOREGROUND

You've probably seen so-called "primitive" paintings in which perspective is ignored and everything looks pretty much the same distance from the observer. One reason for painting that way is to give a picture a childlike, innocent quality. Another is to concentrate on flat, decorative patterns without regard to reality. But in this book realism is what we're after, so we'll use every trick we can to avoid a primitive look and promote an illusion of depth. One way to get that illusion is to use the techniques described here to help distinguish between a picture's background and its foreground.

*Still Life With Bouquet and Apples*
22″ × 30″ (55.9cm × 76.2cm)
watercolor on illustration board

# Overlap

By simply placing one object in front of another you tell the viewer clearly which is closer and which is farther away. In *Inside Out*, shown on page 51, you can easily see several stages of overlap, the most obvious being the overlapping of the white wall by the near brown wall. By overlapping objects, you resolve lots of ambiguities. Without overlap you can be easily fooled, as these examples show:

Here are two objects side by side. Can you tell which is nearer to you? There really are no clues, are there? You might guess the bigger one is closer to you . . .

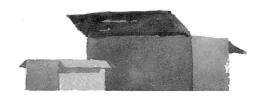

. . . but you might be wrong!

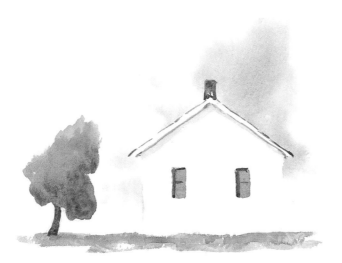

Is the tree in the distance, or the same distance away as the house, or closer to you than the house?

Overlapping the tree and the house eliminates ambiguity and at the same time adds depth to the picture.

## Overdoing Overlap

Overlapped objects must be well chosen and well placed. Suppose the center of interest in your picture is a building. You could place a big rock in the foreground overlapping half the building and helping to "push" the building back. Would that work? Do you really want to hide so much of your building behind a rock? And is a rock an interesting enough object to give it so much prominence? Maybe better choices would be some grasses in the foreground that slightly overlap the building without hiding it. Or maybe a slender tree or a mailbox on a post. The point is, don't just stack things in front of one another. Think about the overall design of your picture.

The rock pushes the building back, but it's not an attractive choice.

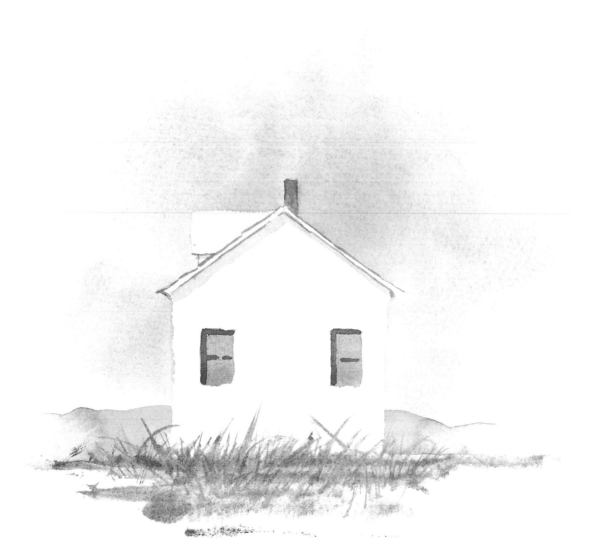

These grasses push the building back more comfortably.

## Overlap Over Short Distances

If you're drawing or painting something that doesn't have miles of depth, such as a still life or perhaps a close-up of a tree, you can still use overlap to great advantage to get that three-dimensional feeling you're after.

**Color Notes**

Bouquet: Alizarin Crimson, Burnt Sienna, Cadmium Yellow, Phthalocyanine Green, Phthalocyanine Blue

Apples: Alizarin Crimson, Cadmium Red Deep, Phthalocyanine Green, Ultramarine Blue

Shadows: Alizarin Crimson, Phthalocyanine Green, Phthalocyanine Blue, Ultramarine Blue

Bowl: Alizarin Crimson, Burnt Sienna, Cadmium Red Deep, Phthalocyanine Blue, Ultramarine Blue

Nuts: Burnt Umber, Burnt Sienna, Ultramarine Blue

Background: Alizarin Crimson, Burnt Sienna, Phthalocyanine Green

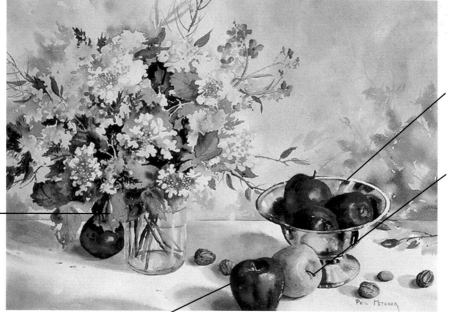

bowl pushes wall back

green apple pushes bowl back

leaf pushes apple back

red apple overlapping green apple pushes green apple back

*Still Life With Bouquet and Apples*
22" × 30" (55.9cm × 76.2cm)
watercolor on illustration board

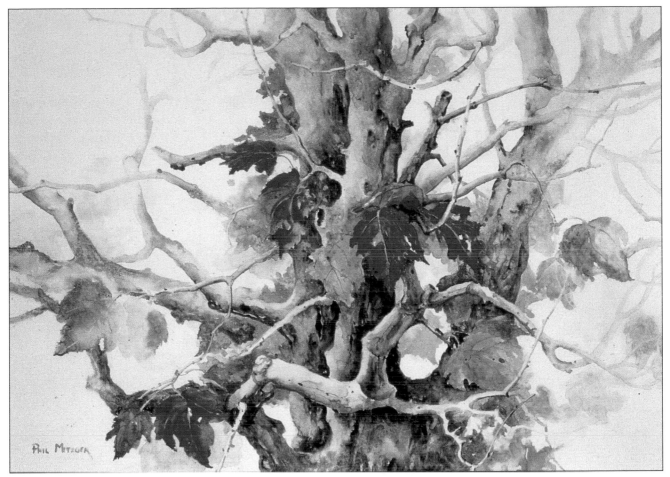

Although distances are short, we can see some modification of edges—the fuzzy leaves hint they're at the rear while the crisp-edged leaves come forward. There is also overlap—leaves overlap the trunk, branches overlap the trunk and branches overlap other branches.

*Red Maple*
30″ × 40″ (76.2cm × 101.6cm)
watercolor on Strathmore illustration board
Collection of Mr. and Mrs. Leonard Lipski

**Color Notes**
Alizarin Crimson
Burnt Umber
Cadmium Red Medium
Phthalocyanine Green
Phthalocyanine Blue
Ultramarine Blue
Yellow Ochre

# Detail and Edges

Do you realize how much your eye resembles a camera? A camera focuses on one distance at a time, and so does your eye. Suppose you take a picture of a couple of wrestlers in a ring. You focus your camera on the sweaty bodies and shoot. When your picture is developed, what do you see? Your heroes come out sharp and distinct. You can make out their hairy legs, their missing teeth—you can almost hear one of them saying "Now it's your turn to fall." In the background are cheering citizens, arms upraised, mouths open, yelling for some blood, but they're less distinct than the wrestlers. The same goes for the people in the foreground, between you and the ring. Even though they're closer to you than the wrestlers, they're less distinct because you focused the camera on the wrestlers. That's the way we see, so that's the way we should paint our realistic pictures. Choose where you want your focus, or emphasis, to be and play down the rest.

In a drawing or painting there are two important ways to change focus, and they usually go hand in hand. You can emphasize detail near the center of interest and you can sharpen edges in that area. Take a look at *Inside Out* on page 51. I chose to make the middle distance the center of interest, so I played down the detail in the nearer and farther areas and softened the edges in those areas. I painted the white boards and the shovel on dry paper to retain crisp edges, but painted on damp paper (wet-in-wet painting) to blur the foreground and background edges.

## Limitations

You have a choice: You can focus on the foreground, the middle distance or the far distance. If your focus is on distant objects, such as mountains, and you blur the foreground and middle ground, it will be hard to make the picture interesting. Most pictures focus on either a foreground or a middle ground area and blur the rest, as in these examples.

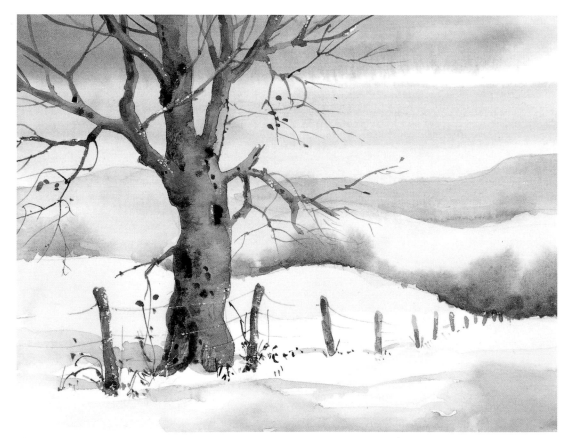

Here the focus is on the foreground. Everything in the middle and far distance is played down and undetailed.

*Tree and Fence*
11" × 15" watercolor on Arches 140-lb. cold press paper
Collection of Lori and Douglas Kraus

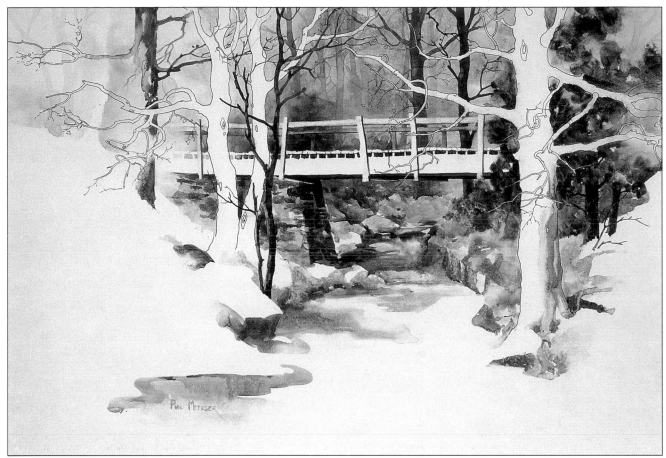

The focus is on the middle ground. The foreground fades toward you and the background fades away from you.

*Woods Bridge*
22″ × 30″ (55.9cm × 76.2cm)
watercolor and inkline on illustration board

**Color Notes**
Burnt Sienna
Burnt Umber
Phthalocyanine Blue
Phthalocyanine Green
Raw Umber
Ultramarine Blue

The foreground and the background (what you can see of it) are muted and undetailed. If you eliminate the soft foreground entirely, you have a picture with less depth. The foreground helps lead the eye into the middle ground, where the action is.

*Shed*
15″ × 22″ (38.1cm × 55.9cm)
watercolor on Arches 140-lb. (300gsm) cold-press paper

### Color Notes
Ultramarine Blue
Burnt Sienna
Phthalocyanine Green
Raw Umber
Raw Sienna

### Check It Out
Not convinced that some things should be out of focus in a picture? Try this: Concentrate on seeing objects at varying distances from you and see how out of focus other objects will be. For instance, I'm sitting at my computer and looking around the room. An object near me is a keyboard. An object a little farther away is my dog, patiently waiting for me to take him for a walk. Across the room are bookshelves. If I concentrate on the dog, both the keyboard and the books are blurry. If I concentrate on the books, the dog is blurry (he doesn't like that so I'd better concentrate on him again). The point is, you cannot focus on more than one distance at a time. Paint your pictures that way.

# A Second Look

This chapter discusses three perspective techniques: overlap, detail and edges. As you see, this picture has séveral layers of overlap—the near wall overlaps the middle wall, which in turn overlaps the fence, which overlaps the foliage. Detail is concentrated in this case in the middle distance (the white siding) and the nearest and farthest areas are left less detailed. Similarly, edges are sharper in the middle distance than up close or far away. Techniques such as aerial and linear perspective, discussed in other chapters, also play their parts.

**Color Notes**
Alizarin Crimson
Burnt Umber
Burnt Sienna
Phthalocyanine Blue
Ultramarine Blue

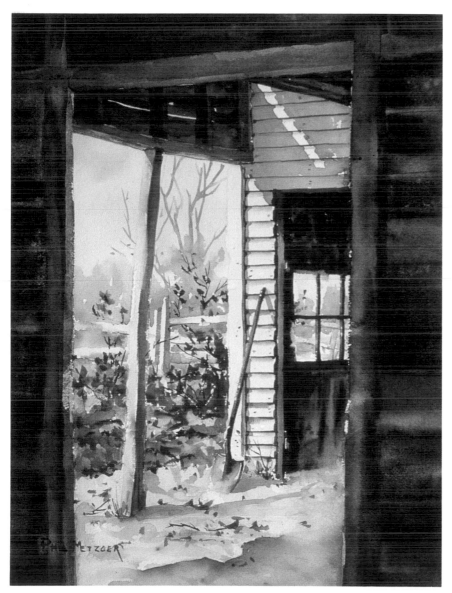

*Inside Out*
30" × 20" (76.2cm × 50.8cm)
watercolor on Strathmore
illustration board

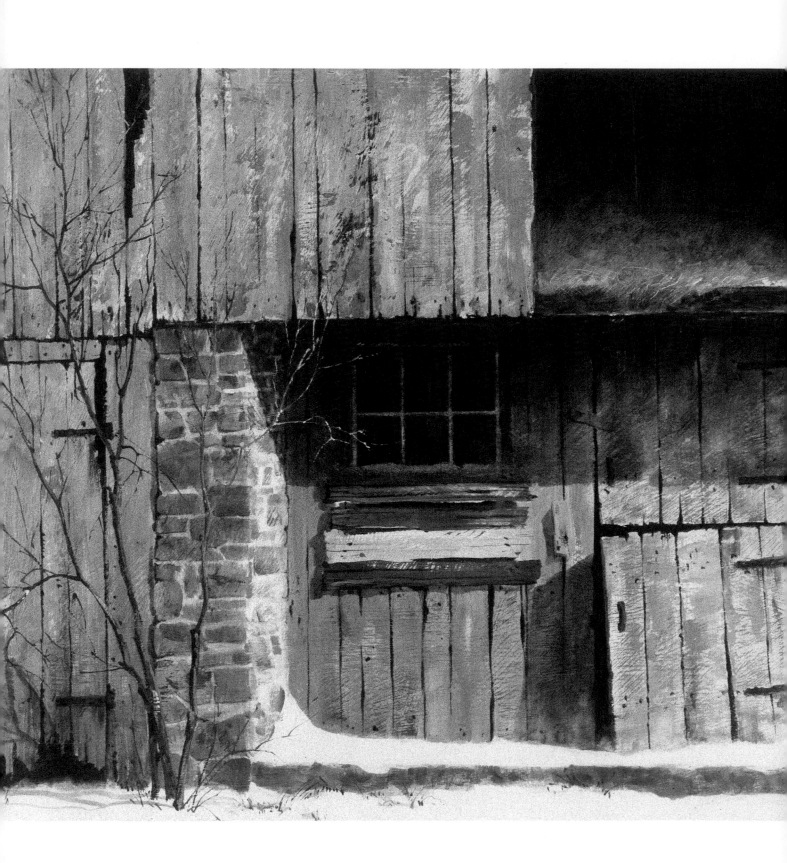

# CREATING DEPTH OVER SHORT DISTANCES

A shadow is an area from which light is partially blocked. If a tree casts a shadow on the lawn, the grass in the shadow area appears darker than the surrounding grass—darker, but not black. In most cases there is plenty of light and color within a shadow.

You can categorize shadows in many ways, but for our purposes let's consider three:

- Shadows that offer strong value contrasts
- Gentler shadows called modeling
- Cast shadows

And for much more on shadows and many other aspects of light, see *Enliven Your Paintings With Light*, North Light Books.

*Barn Overhang*
20″ × 24″ (50.8cm × 61cm)
watercolor on Strathmore
illustration board

# Value

Value means lightness or darkness. A light area is said to have a high value and a dark area has a low value. The term can be applied to either a colored or a black/gray area. The lowest value is black and the highest, white. A so-called mid-value is somewhere between black and white.

low value                                    high value

## Strong Value Contrasts

You can use a very dark spot to punch a hole in a lighter surface. For example, the doors and windows and cracks in *Barn Overhang* at the beginning of the chapter break the monotony of the flat wall. The darks seem to let you see into the spaces behind the wall. Without those rich darks, the picture would have little sense of depth.

**The Shadow Knows**

Do you remember a radio character called The Shadow? His job was catching bad guys and his technique was to make himself invisible. But he was obviously misnamed, because real shadows, after all, are anything but invisible! And they're usually full of color!

Here is the face of a building with no dark accents.

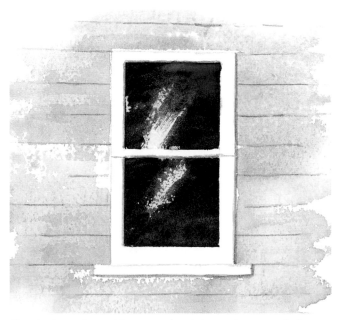

The dark window adds some depth by making you feel you can see into the building.

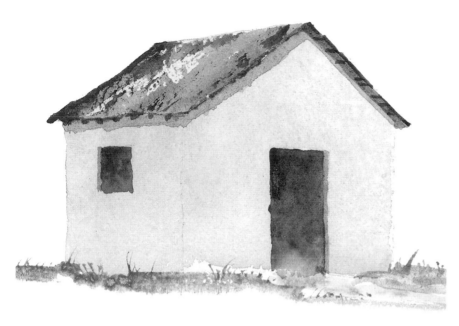

Since the two sides of this building are equally sunlit, there is little sense of depth.

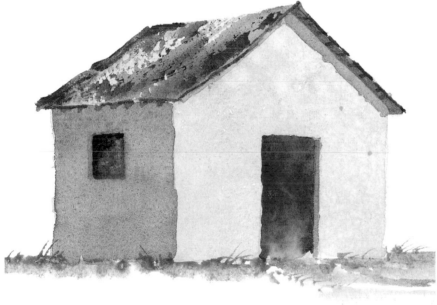

An abrupt shift in values helps lead the eye around the corner and deeper into the picture.

This row of foliage looks fairly flat.

A few darks punch holes in the foliage and draw the eye in.

# Modeling

While strong, abrupt value changes are useful, so are more gradual contrasts. Softer, gentler value change is called modeling (or shading). A head is given form and thickness by paying attention to the gradual darkening of the side of the head away from the light source. A tree is made to look rounded by lighting one side and gradually darkening the other. Although modeling can be used on any size curved object, often it's used when drawing or painting smaller objects, such as bowls and poles and apples and fingers and heads. Modeling may be used effectively on objects only a few inches deep.

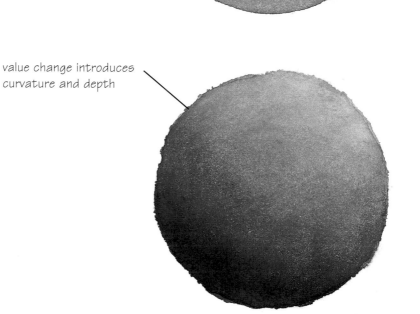

no value change, so this looks flat

value change introduces curvature and depth

pretty flat!

a little more edible

This tree is two-dimensional. With just a little modeling it can be given some form, or thickness.

## Reflected Light

To model the apple in the last section, and thus give it thickness, we shaded it darker and darker around its curve away from the light source. You'd expect the shading to be darkest on the side directly opposite the light source, as in the example, but sometimes that's not the case. Nearby may be lots of other objects— a tablecloth, a bottle, a bowl, another apple. Light reflected from those objects may strike the dark side of the apple and brighten it and probably alter its color. In fact, color from all objects can reflect and strike all other objects so there may be subtle color changes going on all over the place. Whatever you're painting, look for reflected light and use it to add more interest to your picture.

Whether reflected light is noticeable depends on how close the objects are, their relative positions, and how strong the reflected light is. If you have a white silo alongside a red barn, for example, you may well see some red reflected in the silo. In the still life in the last chapter many objects are affected by reflected light. The nut and the apple, for instance, are clearly reflected in the silver bowl; there is also a bit of reflected red in the shadow cast by the red apple.

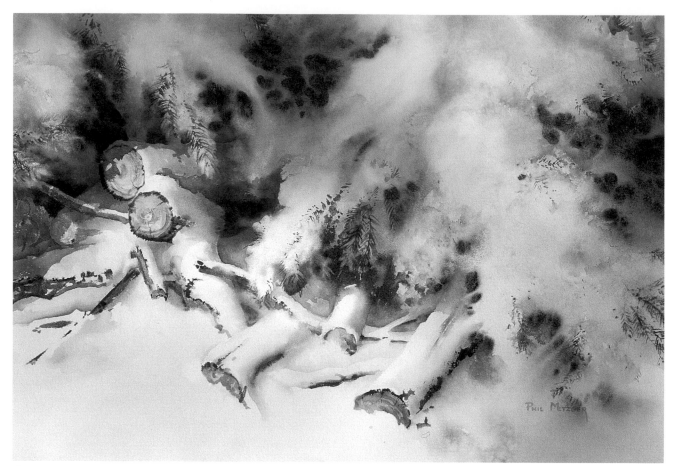

This is a scene out the window of a house I lived in years ago. In this case we have both strong value contrasts, which help lead the eye back into the dark areas, and modeling that gives shape to the branches and logs. If you imagine eliminating either the darks or the modeling, you'll see a rather flat picture.

*Logs in Snow*
22″ × 30″ (55.9cm × 76.2cm)
watercolor on Arches cold-press paper

# Cast Shadows

A cast shadow results when some object blocks light from reaching an area. Most cast shadows are fairly sharp, but many conditions may make the edges of the shadow fuzzy. For example, if you have more than one light source (such as two or three lamps) the light from one source invades the shadow from another source and results in softer edges.

Take a good look at cast shadows and you'll find they are not uniform in value or color. Again, there are lots of reasons for this. For example, reflected light from surrounding areas may bounce into the shadow area. Also, the color and value of the area over which the shadow falls may vary—the value and color of the shadow over, say, a light tan road will be lighter and warmer than the part of the shadow that falls over some adjoining dark green grass.

If a cast shadow falls from left to right or right to left it won't help much to establish depth in your picture. But if you place your light source so that shadows are cast toward the background or foreground, that may add a great deal to the suggestion of distance.

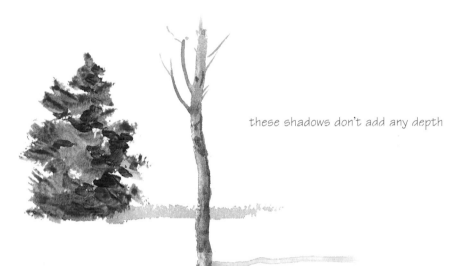

these shadows don't add any depth

these do

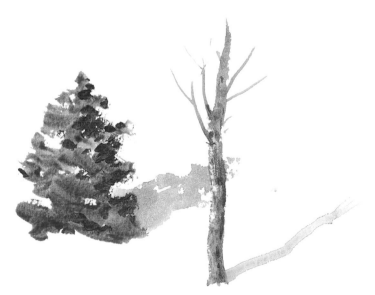

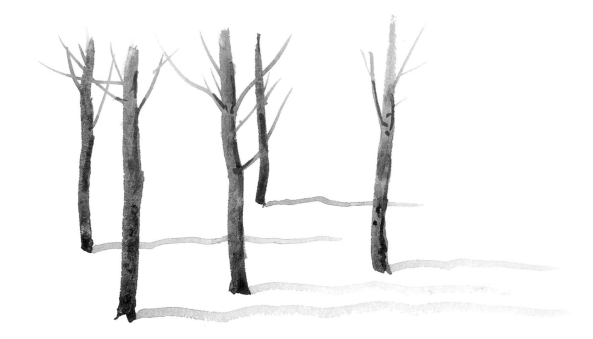

Shadows extending across the picture
don't help give the picture depth.

The light source (sun) is behind the
trees. The shadows cast by the trees
over relatively flat ground will fan out
as shown here—this is an example of
linear perspective, discussed later. If
the ground were curved in various ways,
the shadows might do strange things,
but of course they would always follow
the shape of the ground.

# Cast Shadows Over Short Distances

There's no need to always be thinking of grand distances when we discuss perspective. You can do a lot to make your painting convincing if you show such details as the thickness of an object or how far one object protrudes beyond another. This is important in most still lifes, where you're usually dealing with short distances, but it may also be important when depicting details in a landscape, such as the walls of a building.

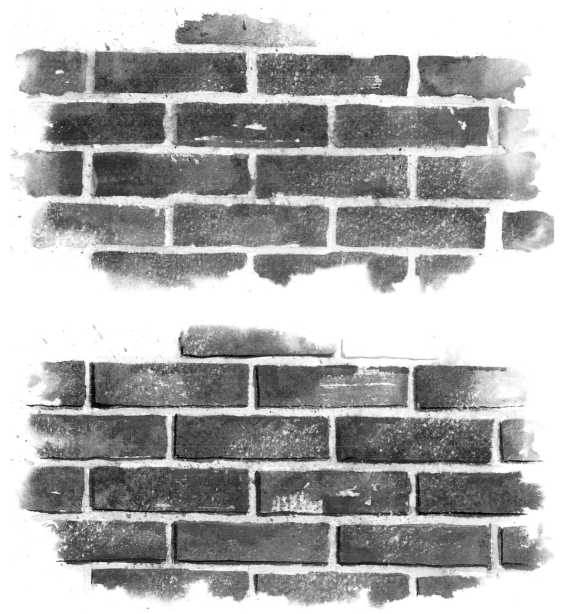

Without shadows these bricks look pretty flat. By casting shadows we show that the bricks protrude a little from the mortar that holds them together.

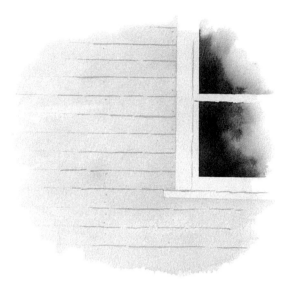

Siding without shadows lacks depth.

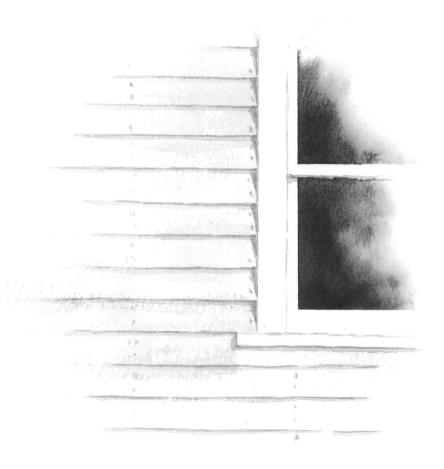

Adding the little triangular cast shadows helps define these boards as the beveled type that overlap each other. The shadows tell you where the sun is and they add interest to an otherwise flat surface. If you were painting a close-up of such a subject, you could show shadows cast by peeling paint, wood slivers, nailheads and so on.

# Using All Three: Sharp Value Contrast, Modeling and Cast Shadows

Rarely do you use one kind of shadow alone. Usually a subject includes all three kinds of shadows to some extent—sharp value contrasts, modeling and cast shadows. If you're seeking ways to make your picture more realistic and more lively, shadows are your friends. They can add dimension, excitement—even mystery—to an otherwise ordinary picture. Often it's helpful to choose a view of your subject that makes the best use of shadows. You may rearrange the lighting on your still-life or portrait subject, for example, to minimize the flatness of the scene. If you're painting a landscape, you might choose a time of day that gives you the most dramatic shadows.

## In Black and White . . .

It's important to get away from your paints now and then and do some sketching with pencils, pen and ink, charcoal or other monochromatic mediums. Working in black and white helps you to concentrate on such things as structure, detail and texture, without the distraction of color.

This tree drawing illustrates all the shadow types we've discussed. There are strong value contrasts to help push things back and pull things forward, while cast shadows and modeling help define the rounded shapes of trunks and branches. As in any picture, you can place your light source wherever you wish to get shadows cast in directions that help you define shapes and suggest depth. And of course you can cast shadows from objects, such as neighboring tree branches, that are not even shown in your picture.

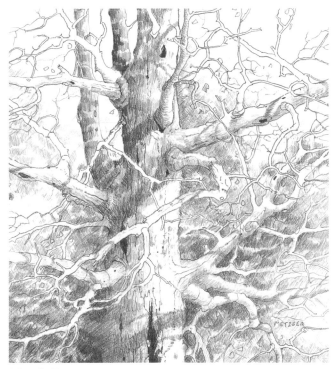

*Woods Textures*
6½″ × 7″ (16.5cm × 17.8cm)
pencil on plate-finish Bristol paper

## . . . And in Color

This picture also uses all three kinds of shadows. The dark background shadows help sculpt the tree trunks and make them come forward, while modeling (shading) and cast shadows help define the forms and dimensions of the object.

**Color Notes**
Alizarin Crimson
Burnt Umber
Burnt Sienna
Phthalocyanine Green
Phthalocyanine Blue

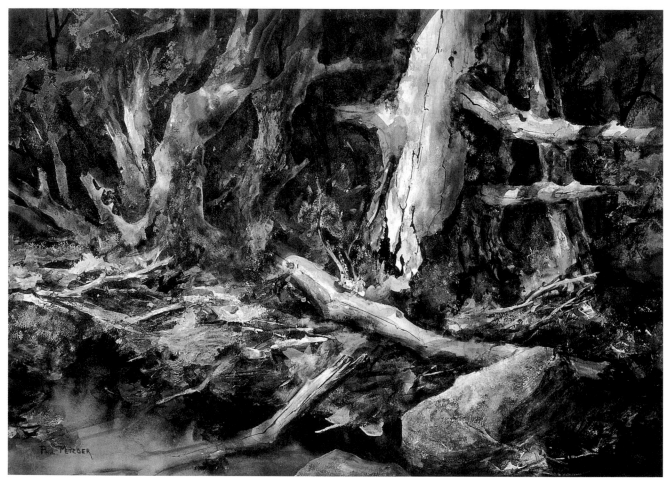

*Woods Light*
28″×36″ (71.1cm×91.4cm)
watercolor on illustration board
Collection of Mr. and Mrs. Bob LaGasse

# A Second Look

Take a quick review of *Barn Overhang* and you'll see how the deep shadows in the doorway and window draw your eye in and establish depth; modeling (shading) in the hay helps the hay recede; and cast shadows help pull the lower door toward you and also push the lower part of the barn back under the overhang.

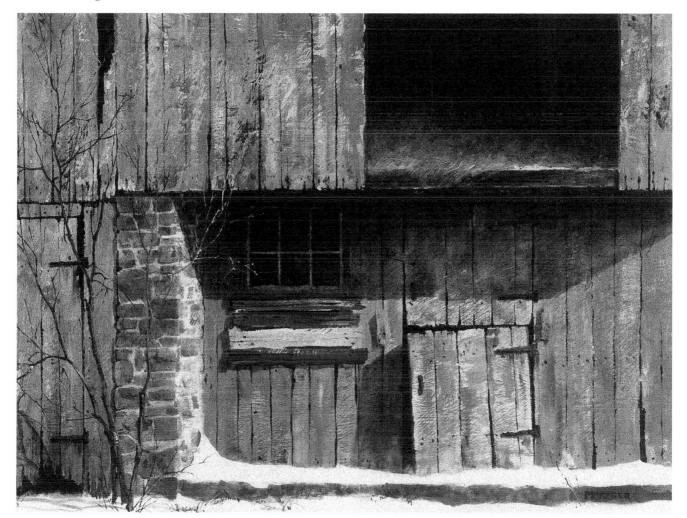

*Barn Overhang*
20" × 24" (50.8cm × 61cm)
watercolor on Strathmore illustration board

**Color Notes**

Weathered wood: Alizarin Crimson, Burnt Sienna, Phthalocyanine Blue, Ultramarine Blue

Overhang shadow: Phthalocyanine Blue, Ultramarine Blue

Hay: Raw Umber, Raw Sienna, Yellow Ochre

Darks: Alizarin Crimson, Burnt Umber, Ultramarine Blue

Stones: Burnt Sienna, Ultramarine Blue, Yellow Ochre

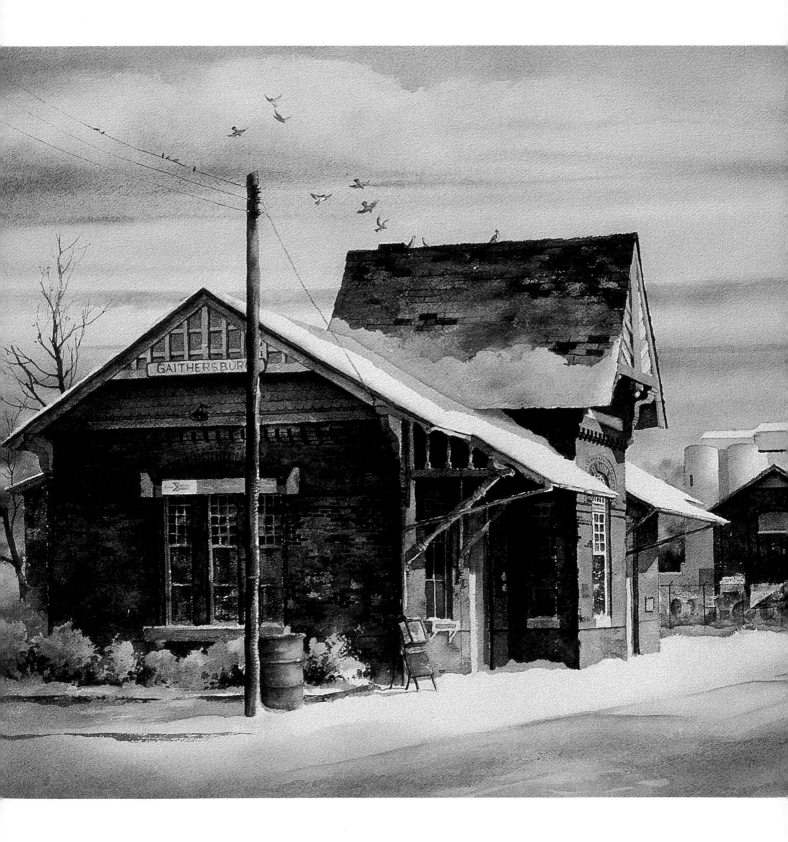

*Sunday Morning
Commuters*
22″×30″ (55.9cm×76.2cm)
watercolor on illustration
board
Collection of Gaithersburg,
Maryland, City Hall

LINEAR PERSPECTIVE PART I:
# THE THIRD DIMENSION

N ow we come to the perspective technique that's often more effective than all the others. Linear perspective practically forces you to see depth in a picture. And despite anything you may have heard, linear perspective is not complicated or mysterious or hard to understand. In fact, it's a technique that's fun to use.

Linear perspective makes use of a phenomenon we're all familiar with: Straight lines that are actually parallel (which means they never really meet) do seem to meet as they recede from us. For instance, if you look down a long, straight railroad track stretching away from you into the distance, the rails seem eventually to come together. You know they don't, of course—otherwise it's bad news for the train. This seeming convergence of parallel lines is at the heart of linear perspective.

# Some Definitions

Let's stick with our railroad track example. Assume the track is straight and lies on level ground. The point where the two rails seem to meet is called the vanishing point—it's where the tracks vanish. The vanishing point lies on the horizon.

## Horizon

Now what is the horizon? If you stand on flat ground and look straight ahead of you, the imaginary line where the sky and the land meet is the horizon. If you look out over an ocean, the line where sky and ocean meet is the horizon. The horizon is always there, of course, but you can't always see it because things like buildings or mountains are in the way. If you could see through those objects, you'd see the horizon beyond them. Because you can't always see the horizon, we use a different term instead: eye level.

## Eye Level

The eye level is an imaginary horizontal plane, parallel to the ground, extending from your eyes into the distance. In the following discussions we'll use *eye level* and forget about horizon.

Let's be sure we're clear about eye level, because it's basic to understanding and using linear perspective. If you stand on level ground and look straight ahead (not down, not up) and imagine a horizontal sheet of glass extending from your eyes out into the distance, the glass represents your eye level. Everything above the sheet of glass is above your eye level and everything below it is below your eye level.

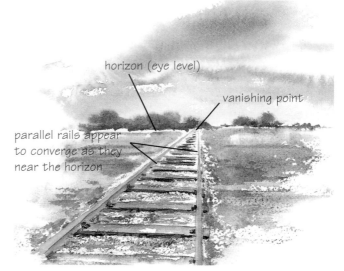

*horizon (eye level)*

*vanishing point*

*parallel rails appear to converge as they near the horizon*

You know the rails are parallel, yet they don't look the same distance apart as they go into the distance. That's the way we see things, so that's the way we should draw or paint them.

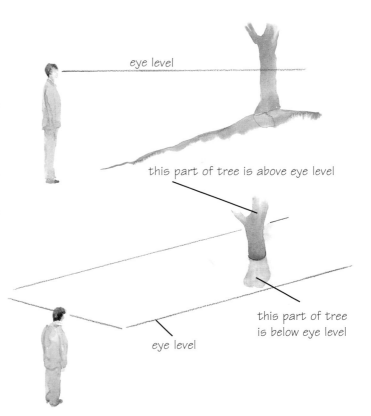

*eye level*

*this part of tree is above eye level*

*this part of tree is below eye level*

*eye level*

If you imagine a horizontal sheet of glass extending from your eyes in all directions, the glass represents your eye level.

*Why Is Eye Level Important?* Suppose your child is alongside you and she is half as tall as you. She's looking straight ahead, just as you are. Her eye level is not the same as yours—it's lower. So she sees a slightly different scene.

When you paint a realistic picture, choose one eye level for that scene and relate everything in your picture to that eye level. If you look at a scene and start drawing your picture standing up, but finish it sitting down, you're using two different eye levels and you're seeing two different scenes!

*Establish Eye Level* I'm not crazy about "rules" in art, but here's one you need to follow if you intend to paint convincing realistic pictures: Start each picture by establishing an eye level and then stick to it.

As soon as you stray from the eye level you began with, you get into trouble. My usual practice is to draw a light line across my picture surface where I want the eye level to be, just as a reminder. Then I relate every object in the picture to that eye level.

### Eye Level

The eye level in a picture tells from what vantage point you viewed the scene as you painted it. Eye level has nothing to do with how high or low the finished picture hangs on a wall. Don't forget: You may place the eye level anywhere you want to—high, low or in the middle of the scene. Once you've established it, put both vanishing points on the eye level.

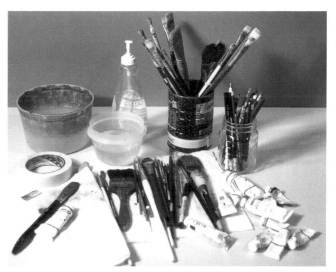

Here is a still-life arrangement seen from a standing position.

This is the same arrangement seen from a sitting position. The eye level here is lower than in the first illustration.

The eye level in this picture is a little below center—I have in mind a landscape with a big sky and a narrower strip of land. In addition to marking the eye level, I usually also mark the center of the picture area with a cross. That's to warn me not to place too strong an object dead center—I prefer designs that don't have an annoying bull's-eye at the center.

# One-Point Linear Perspective

Earlier we discussed something called the *vanishing point*, the place where parallel lines seem to meet. Some pictures have only one vanishing point. All the receding parallel lines in such pictures meet at this single point. DaVinci's *Last Supper* is a well-known example.

Pictures done in one-point perspective tend to be symmetrical and formal. If that's what you're after, this type of arrangement may suit you well. Most pictures, especially modern ones, are done in either two-point perspective or a combination of one-point and two-point (see an example on page 77). Such pictures tend to be looser, less static than those done in one-point.

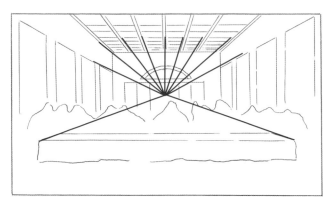

Sketch of DaVinci's *Last Supper*. The single vanishing point is near Christ's head. All receding horizontal lines in the scene converge at that point. The lines above the eye level slant *down* to reach the vanishing point, while the lines below the eye level slant *up* to the vanishing point.

The face of this box is parallel to the picture surface. The receding parallel edges come together (vanish) in the distance at a point that lies on the eye level. Since this box is above the eye level, all its receding lines slant down toward the vanishing point.

face of box is parallel to picture surface

eye level

VP

This box straddles the eye level. I've left off the front and back so you can look through and see where the vanishing point is. Notice that receding lines above the eye level slant down and those below the eye level slant up.

eye level

The face of this box is parallel to the picture surface. Since the box is below eye level, its receding lines slant upward toward the vanishing point.

VP

eye level

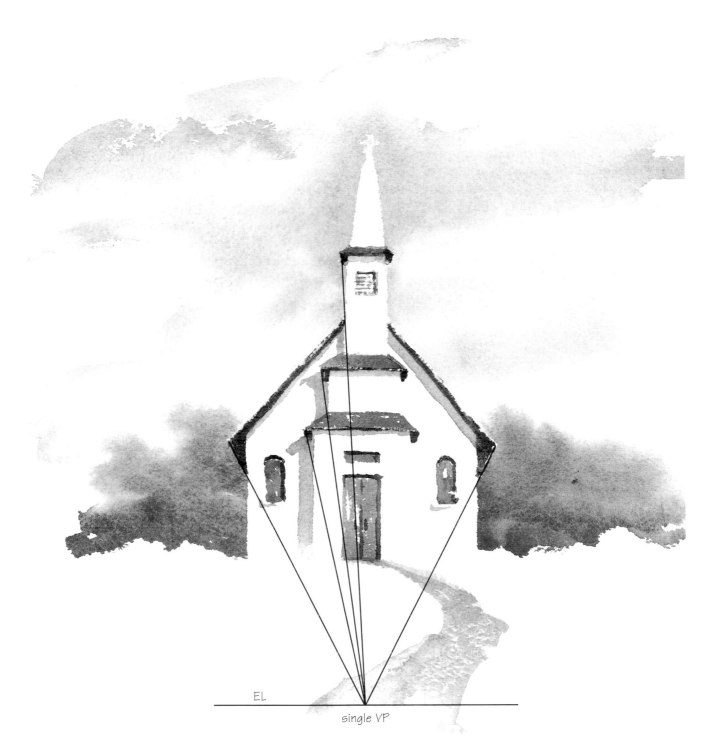

EL

single VP

Here the eye level is low. This is how the building might look to someone standing downhill from the church.

## Up and Down

Receding lines above the eye level slant *down* to a vanishing point; lines below the eye level slant *up* to a vanishing point.

## Color Notes

Alizarin Crimson
Burnt Sienna
Phthalocyanine Blue
Phthalocyanine Green
Ultramarine Blue

# Multiple Object Exercise

Let's put what we've just learned into practice with this multiple building demonstration. The accompanying sketch shows eye level and vanishing points.

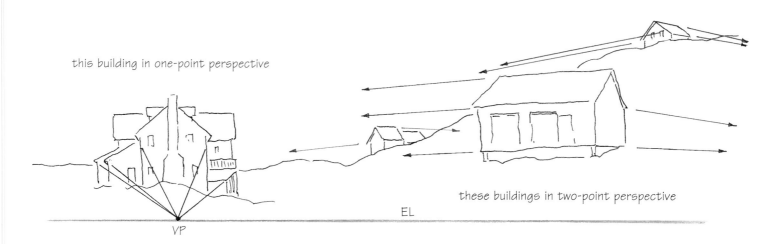

this building in one-point perspective

these buildings in two-point perspective

EL

VP

Sketch of buildings with construction lines.

Step 1: Wet the entire sky area carefully, leaving the building and land area dry. Lay in color wet-in-wet. Use thicker color for the blurry trees.

Step 2: Paint some rough color over the land area, using lighter versions of the colors in the sky.

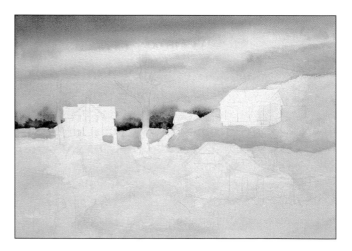

Step 3: Begin detailing the buildings and trees.

**Color Notes**
Burnt Sienna
Cadmium Red
Cobalt Blue
Phthalocyanine Green
Phthalocyanine Blue
Ultramarine Blue

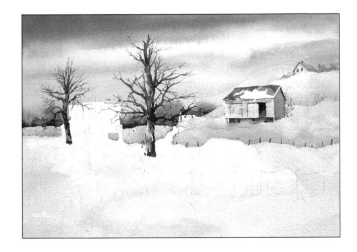

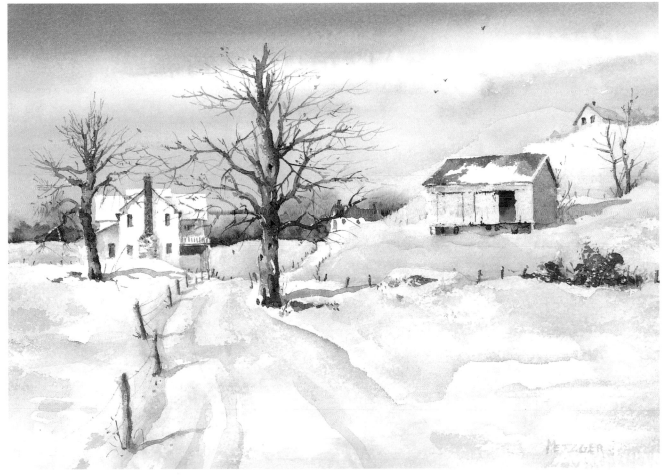

Here are buildings at different elevations. The house on the left is in one-point perspective, all the others are in two-point. The eye level is shown in the accompanying sketch. Most of the vanishing points are off the page to the right or left.

# Multi-Point Perspective

Parallel lines that recede into a picture always appear to meet at a point we call the vanishing point. *Horizontal* receding lines meet at vanishing points *on the eye level*. But in many pictures there are other parallel lines—lines that are not horizontal—and they do not meet on the eye level. They meet somewhere else.

There can be many such sets of parallel lines—the number of possibilities is infinite. But life is short, so we'll boil everything down to two common kinds of lines that meet at vanishing points not on our eye level: vertical lines and sloping lines.

## Vertical Lines

In all the preceding discussions we've ignored vertical edges. In most one- and two-point drawings, you can leave vertical lines vertical and forget about them. That's because they're relatively short and you're looking at them from a distance, so you don't notice any convergence. But suppose you're on the street looking up at a tall skyscraper. Now the vertical lines are not so short and you're not seeing them from a distance. The vertical edges do seem to converge as they reach skyward, just like the rails of a railroad track if you stood the track on end. The point where they seem to converge is a new vanishing point. It does not lie on normal eye level.

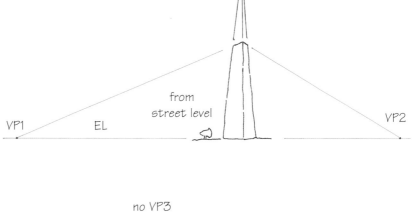

Suppose you're on the sidewalk looking up at a skyscraper whose faces are rectangular. This is what you'd see. The edges of the building (parallel lines) seem to converge. Somewhere in the sky above the building those edges "meet" at a vanishing point.

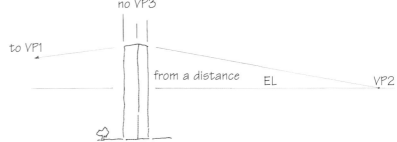

The same skyscraper viewed from a distance from another skyscraper's window would look like this.

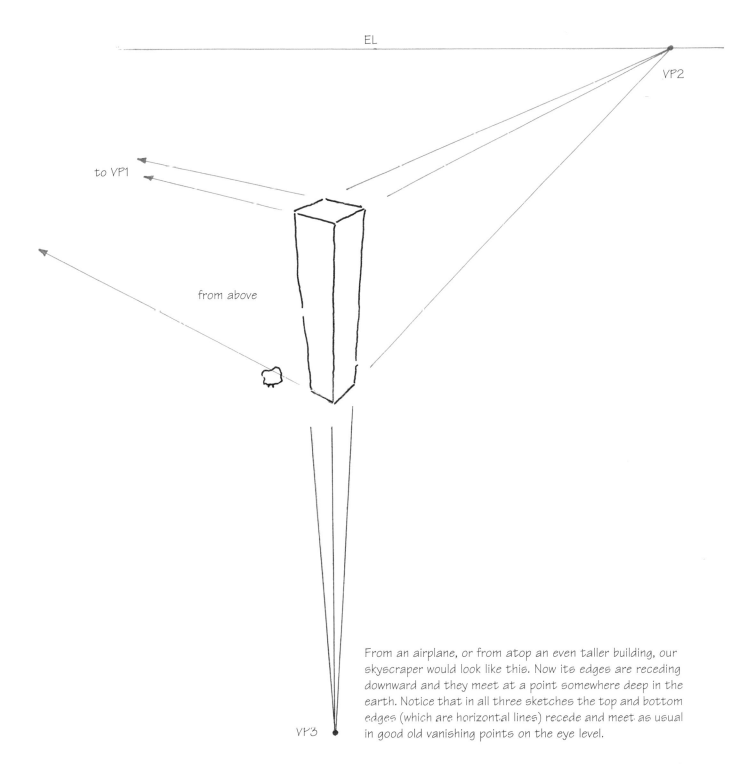

EL

VP2

to VP1

from above

VP3

From an airplane, or from atop an even taller building, our skyscraper would look like this. Now its edges are receding downward and they meet at a point somewhere deep in the earth. Notice that in all three sketches the top and bottom edges (which are horizontal lines) recede and meet as usual in good old vanishing points on the eye level.

**Birds and Worms**

When you choose a bird's-eye view or a worm's-eye view of tall objects you may place the third vanishing point as high or as low as you wish. The closer you put a vanishing point to the object, the more distorted the object will appear, just as in two-point perspective. Choose your vanishing points' positions to give you the amount of distortion you want.

## The Third Vanishing Point

Tall objects viewed from a high or a low vantage point, such as these skyscrapers, have a third vanishing point in addition to the normal two points. Each object has its own set of vanishing points. Vanishing points 1 and 2, as always, lie on the eye level; vanishing point 3 does not lie on the eye level, but somewhere above or below eye level.

## Sloping Lines

In almost any landscape with buildings there are parallel lines that are neither horizontal nor vertical, but sloping. An example is a slanted roof. Its two tilted edges are parallel, and since they are receding from us they'll seem to meet at some point if you extend them far enough.

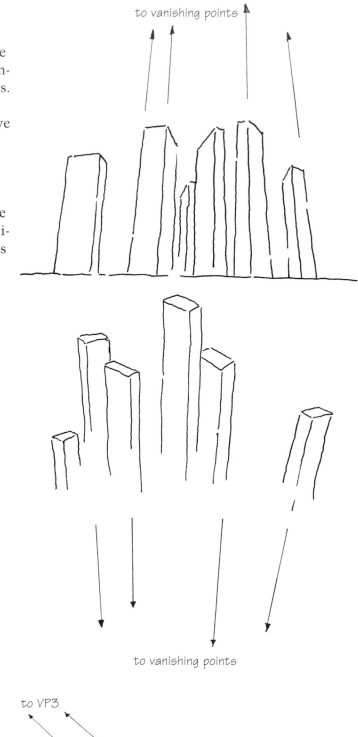

to vanishing points

to vanishing points

Roof surfaces like these are tilted away from you, so their parallel side edges are receding from you and those edges meet in the distance. They meet at vanishing points not on the eye level. Notice that both roof surfaces (the one you can clearly see and the one on the other side of the barn) are slanted away from you.

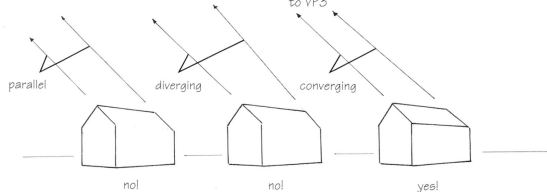

parallel    diverging    to VP3    converging

no!         no!          yes!

# A Second Look

This painting is a good example of how linear perspective points the eye into the distance and creates an illusion of depth.

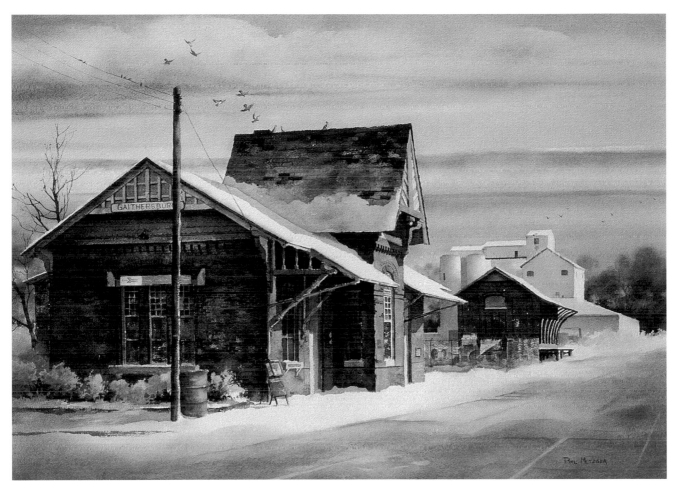

*Sunday Morning Commuters*
22″ × 30″ (55.9cm × 76.2cm)
watercolor on illustration board
Collection of Gaithersburg, Maryland, City Hall

## LINEAR PERSPECTIVE PART 2:
# PUTTING IT TO WORK

With the basics of linear perspective under our belts, let's put these ideas to work in a practical way. Mostly we'll discuss drawing or painting rectangular objects, such as barns, boxes and houses, because they're familiar subjects. We'll begin by reviewing some drawing techniques that help get distances and angles and shapes correct.

*The Old Mill*
11″×15″ (27.9cm×38.1cm)
watercolor on Arches cold-press paper
Collection of Jeffrey and Nancy Metzger

# Measuring Things

There are usually two kinds of measurements you make when you do a drawing: distances and angles. Distance may mean the space between a pair of buildings or between an apple and a bowl. Or distance may be the length or width or height or diameter of an object. All these distances may be measured accurately enough by the thumb-and-pencil method discussed in an earlier chapter. You close one eye and hold at arm's length a straight-edge, such as a pencil or a ruler, and use your thumb to mark off a distance. Then you compare that distance to another marked off in the same way. You find that distance A is about three times distance B (your thumb is three times farther down the pencil for A than for B). On your drawing you mark off similar distances—if you start by making B one inch on your paper, you make A three inches. All you're doing is finding out the relative sizes of things.

Once you've sketched lines that mark off distances, or sizes, you need to check on angles. In linear perspective your drawing will be convincing only if you get the angles right. An angle is a measure of the direction of one line compared with the direction of another: the slope of a roof compared with the vertical side of the building, the slope of the top of a doorway compared with the side of the doorway, the slope of a table edge compared with the vertical edge of a wine bottle.

## Accurate Angles

How can you get the angles right? Again, you can hold the pencil or ruler at arm's length and line it up with an edge you're working with, such as the top of a doorway. Then, trying not to let your hand wobble or your wrist twist, move the pencil to your drawing and lay it flat against the drawing. The slope of the pencil as it lies on your drawing, with a little luck, will be the slope of the top of the doorway. But a lot can happen as your arm moves down to your drawing and the result you get may not be accurate.

Here's a better way to measure angles and slopes quickly and accurately. If you have a folding carpenter's ruler, use it. Otherwise, make a measurer by hinging together two strips of wood or mat board. Hold the strips at arm's length, close one eye and line up one edge with an edge in your subject, such as the vertical edge of a doorway. Rotate the other leg of your measurer to line up with the top edge of the doorway. Now you have the angle between the vertical edge and the sloping top edge. Move the gadget to your paper and copy the angle. You can measure all kinds of things this way accurately and easily.

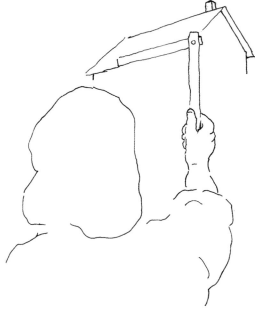

Use this simple gadget to measure angles and the slopes of lines in your subject. Line up the jaws with what you're measuring, lay the jaws against your paper and copy the angle.

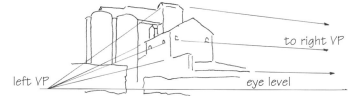

left VP        to right VP     eye level

Sketch of *The Old Mill* showing accurately measured angles and vanishing points.

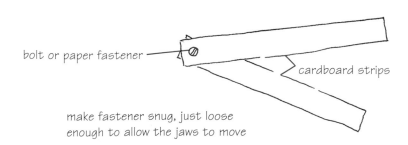

bolt or paper fastener     cardboard strips

make fastener snug, just loose enough to allow the jaws to move

# Drawing Through

A great way to draw a shape convincingly is to "draw through" the object—that is, draw the lines you can't see as well as those you can. It's like imagining the object to be transparent so you can see all its sides and edges. Drawing through is a great help in getting linear perspective right, whether you're drawing a simple box or a more complex subject.

learn to "see" the hidden edges

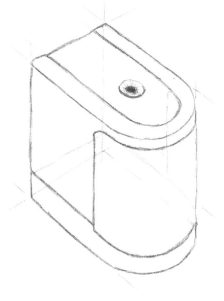

Here are some objects "drawn through." This drawing technique helps you visualize what's on the other side of the mountain! Use faint lines when drawing through so you can erase them or cover them with paint easily. Drawing through is particularly helpful for curved lines, such as ellipses (circles in perspective)—we'll cover them in the next chapter.

curves are easier to draw if you draw them all the way around

draw the unseen sphere of the eyeball and wrap the lids around it

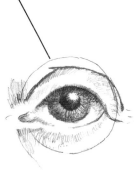

try to see the chimney as a box

the dormer is like a small house pasted onto a larger house

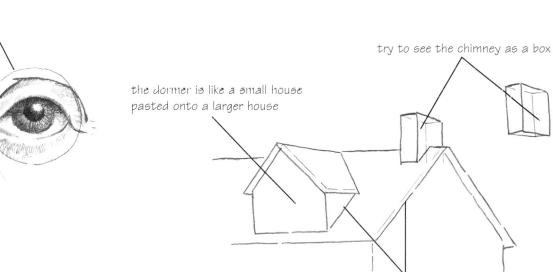

these lines are parallel

# Finding the Perspective Center

When you show a rectangle in perspective, its center is no longer halfway between its sides. The center shifts. At its new location we call it the *perspective center*. To locate it, draw the rectangle's diagonals; where they cross is the perspective center.

Why do we care where the perspective center is? Suppose the rectangle in the last illustration is the side of a house and you want to place a door in the middle of that side. You could do it by placing the door halfway between the two vertical edges, but you'd be wrong! There should be more space between the door and the near edge than between the door and the far edge.

Notice that the door in perspective is not evenly divided, with one-half to the right of perspective center and one-half to the left. There is more of the door showing on the near side than on the far side. That's because the door, as well as the side of the house, is in perspective.

## Getting the Angles Right

Here's a way to practice getting angles right. Mount a sheet of glass (or Plexiglas) between you and a scene and draw the scene directly on the glass, using a marker. You'll easily reproduce the scene with no chance of getting angles wrong. You simply copy what you see through the glass. You can use one of your house windows or your car window if there's an appropriate scene outside, provided you use a marker that can be easily erased. Another option is to tape a sheet of transparent paper or Mylar or similar material to the glass and draw on that surface instead of on the glass. When you're finished, you'll have an accurate drawing you can trace onto your watercolor paper.

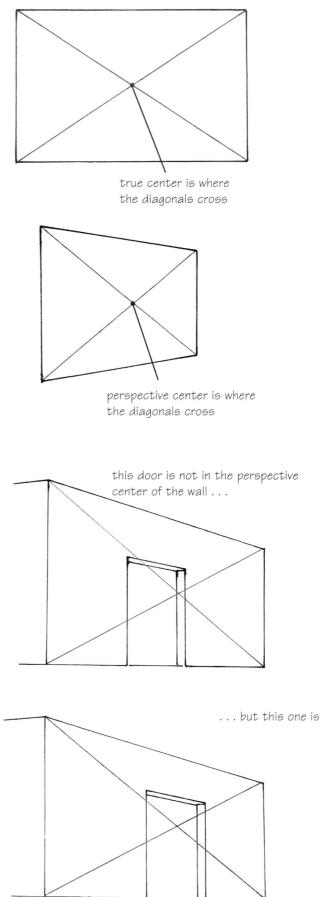

true center is where
the diagonals cross

perspective center is where
the diagonals cross

this door is not in the perspective
center of the wall . . .

. . . but this one is

# Doors, Windows and Other Details

They say the devil is in the details. The shape and placement of small items such as windows and doors can affect how reasonable your drawing or painting looks. Sometimes an otherwise sound drawing is unconvincing because details are not right. Remember that many kinds of details are simply one rectangle (such as a window) placed within another rectangle (such as a wall). Recall also the lessons of earlier chapters: Just as receding fence posts seem to diminish in size and spacing, so do windows and doors (or bricks or shingles). Later we'll build an entire house from scratch, but first let's look at doors, windows and chimneys. (For more detailed examples, see *Perspective Without Pain*, North Light Books.)

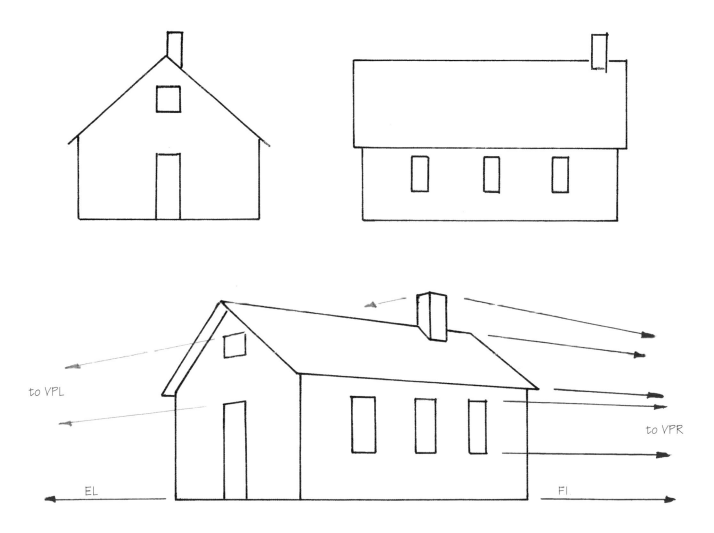

Looking at this house flat-on, the side of the house, the door, the window and the chimney are all flat rectangles. In two-point perspective all these rectangles obey the rules of linear perspective. One set of perspective lines aims toward the right-hand vanishing point and the other, toward the left-hand vanishing point. Notice the steepest slants belong to the lines that are the farthest above or below the eye level, in this case, the chimney-top edges.

The red lines meet at a vanishing point off the page to the right; green lines meet at a left vanishing point. The windows get progressively smaller as they recede and so do the spaces between them. The little window in the gable end of the building might at first appear to be placed too far right, but that's only because the overhanging roof hides part of the wall from view. If you draw through and "see" the underlying edge of the wall, you'll see that the window is placed properly in the perspective center of the wall.

# Let's Build a House

Now that we've discussed the basics of linear perspective and how to handle some of the details, let's put it all together. Imagine you're constructing a house on paper. We'll do this in two-point linear perspective, so all receding horizontal lines will meet at one of two vanishing points. All vertical lines remain vertical. We'll do some drawing through to help visualize what's going on. (Once you master this exercise, you get your architect's degree.)

Step 1: Choose an eye level, EL. Place VPL at the left and VPR at the right, both on the eye level. Then draw a line for the nearest vertical edge of your building. If at any time during this construction you don't like where you've placed the vanishing points, move them and start over. You may need to tape on a piece of paper, as I did, to place VPR because it falls beyond the edge of the drawing paper.

VPL

Step 2: Connect the top and bottom of the vertical edge to both vanishing points.

Step 3: Draw two vertical edges representing how long you want each side of the house to be. Now you can see two walls of the house.

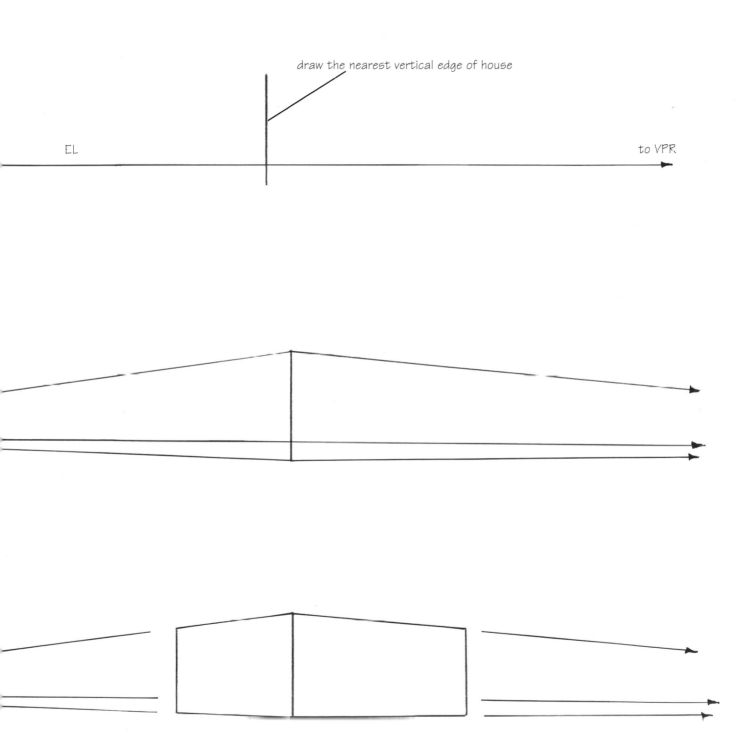

draw the nearest vertical edge of house

EL

to VPR.

Step 4: Now let's find the hidden rear walls. Connect the vanishing points with the tops and bottoms of the two edges you just drew.

Step 5: Draw a vertical line between the two points where the last construction lines cross. Now you can "see" the two hidden walls (imagine you're looking through a glass house).

Step 6: Next we'll draw the house gables (the triangular upper parts of the two end walls).

Start by finding the tip of the front gable. The tip will lie along the vertical line that runs through the perspective center of the wall. Draw the wall's diagonals and run a vertical line through the point where the diagonals cross. The tip of the gable lies somewhere along that line. Put a dot where you want the tip to be (you may make the roof as steep as you wish) and connect that dot with the top corners of the wall.

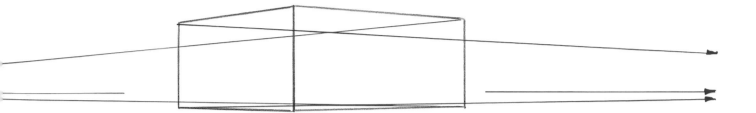

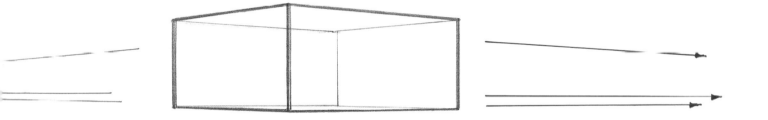

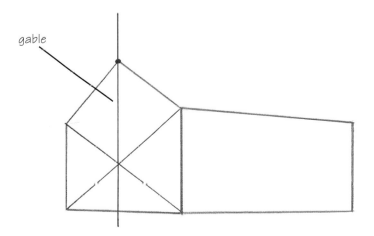

gable

Step 7: Notice the gable you've drawn is not a symmetrical triangle—that's because it's in perspective. Now draw the roof ridge line (the top edge of the roof). To get it right, draw a line from the gable tip to VPR. Now you can draw the rear gable—you know how high it is (up to the roof ridge line) and you find where its tip lies by drawing diagonals and running a vertical line through the perspective center of the rear wall—the same way we treated the front wall.

Step 8: Now we'll add a roof. You need to have a reasonable-looking roof if your picture is to be believable. First, draw a line parallel to the edge of the front gable to indicate how far you want the end of the roof to stick out.

Step 9: Now mark off how far toward the ground you want the roof to overhang along the long sides of the house—I've shown this mark as point X. Draw a line through X toward VPR.

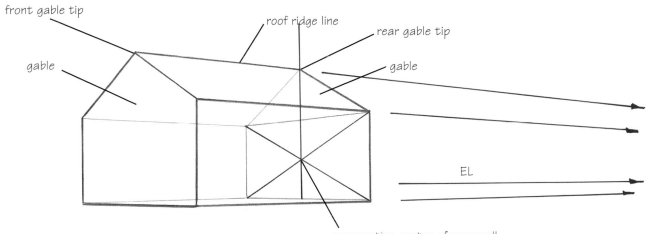

front gable tip

roof ridge line

rear gable tip

gable

gable

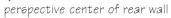

EL

perspective center of rear wall

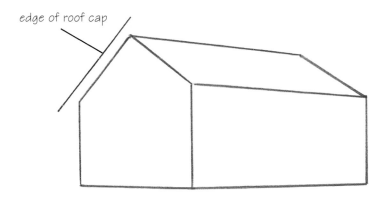

edge of roof cap

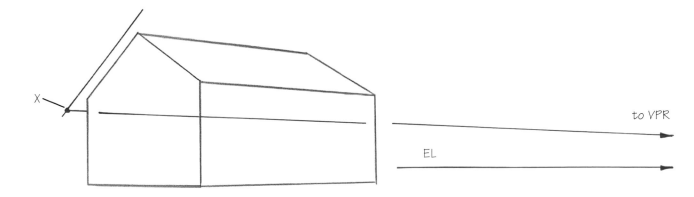

X

to VPR

EL

Step 10: We've found the front edge of the overhang on the left side. Now we need the overhang edge on the right side. Draw a line from VPL through X. Then draw a line from the front roof tip (I've called this Y) parallel to the edge of the gable. Where this line intersects the last line is the near tip of the overhang (point Z). Draw a line from Z to VPR and the roof is nearly finished.

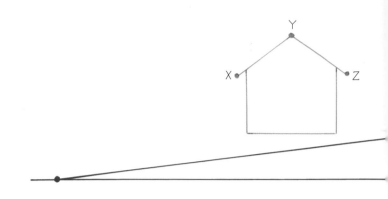

Step 11: Now finish the roof by drawing a line to show its far edge.

**All Those Construction Lines!**
Construction lines illustrate how linear perspective works. You need not actually draw any of them unless your picture is in trouble and you need to figure out what's wrong.

Step 12: Add a chimney. Start by drawing a vertical line where you want the nearest vertical chimney edge to be. This is akin to the first step in building the house itself—just think of the chimney as a little rectangular house stuck onto the bigger rectangular house.

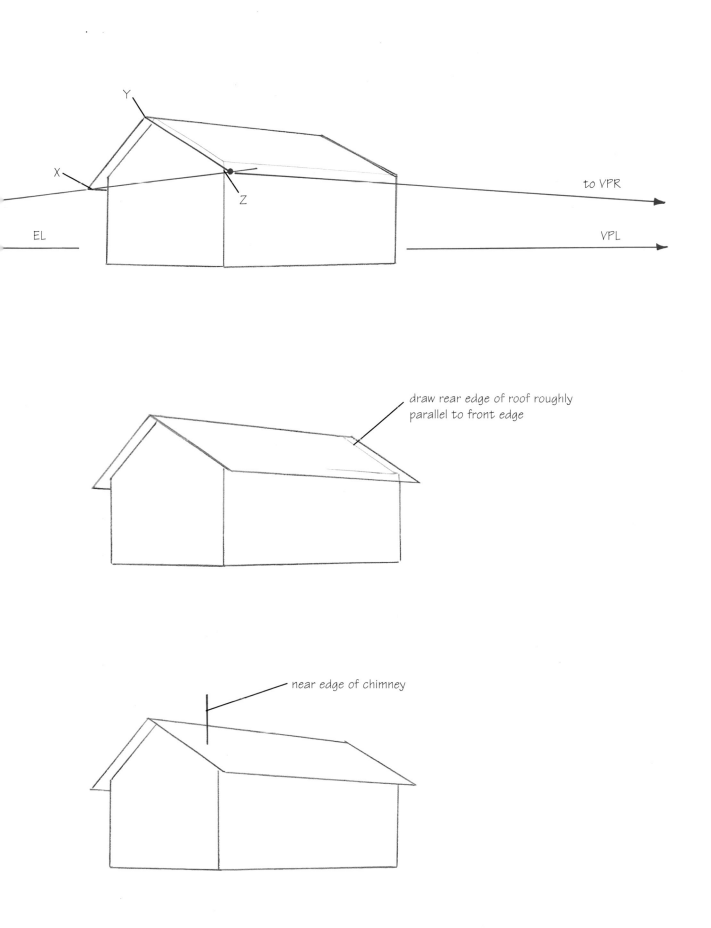

Y

X

Z

to VPR

VPL

EL

draw rear edge of roof roughly
parallel to front edge

near edge of chimney

Step 13: Place a dot to mark the height of the chimney. Then draw construction lines to both VPR and VPL. Draw lines to show where the chimney intersects the roof—the left line will be parallel to the front roof edge. Draw vertical lines to show how wide you want both faces of the chimney to be.

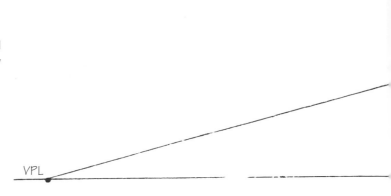

## Moderation

Linear perspective pretty much duplicates what a good camera would record, yet the result isn't always pleasing. People have certain psychological leanings that make them sometimes favor pictures in which the rules of linear perspective are bent considerably. One study showed, for example, that people preferred groupings of receding poles that did not recede quite as rapidly as linear perspective would dictate. Clearly, you should fix your perspective to make it look comfortable. There is another limitation you should keep in mind. Linear perspective is only useful within the normal human cone of vision—essentially the area you can see without moving your head. Outside the cone of vision—that is, in peripheral vision—things look distorted. Cameras have the same problem. You've probably seen paintings that are copies of photographs made by cheap cameras—the photograph is distorted around its edges, and so is the painting!

Step 14: Let's finish up with a door and a couple of windows. Draw them as explained in an earlier section. Your basic house is done.

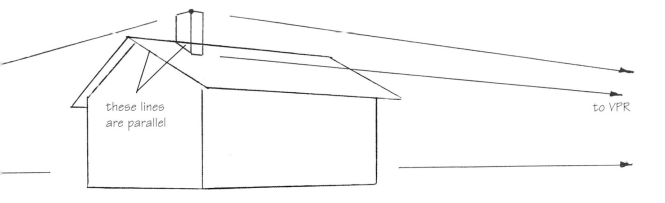

these lines
are parallel

to VPR

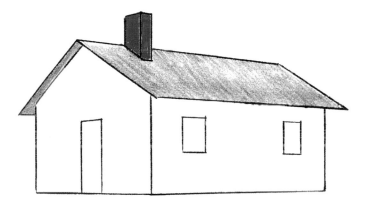

# The Real World

Perspective rules are violated all the time, sometimes resulting in a bad painting. But often you need to violate the rules to make your subject look real. In this illustration a number of things violate, or appear to violate, the rules of perspective. The roof lines of the left-hand shed, receding to the right, suggest that the eye level is roughly halfway up the picture. That would put the front edge of the shed's porch just about on the eye level, so that edge should be horizontal. But instead it slants decidedly upward toward the left. The reason is the sheds, and especially the porch held up by two poles, are old and dilapidated.

The right-hand shed suffers from the same malady—age—so it's sinking and the front edge of its roof points too sharply upward. Look at the right wall of that same shed. If it were a neat, symmetrical wall, like those we've been dealing with, the rear roof would need to drop about as low as the front roof. It doesn't, because the shed was built with an asymmetrical end shape.

I think you'll agree the picture feels right despite these departures from pure linear perspective. In fact, had I straightened things up I probably would have made a less interesting picture, lacking the charm of age. Depart from the so-called rules when it makes sense. One thing is certain: If you know the rules to begin with, you can depart from them in ways that look believable. Knowing what age had done to these buildings I was able to violate rules I knew well without coming up with a result that looked wrong.

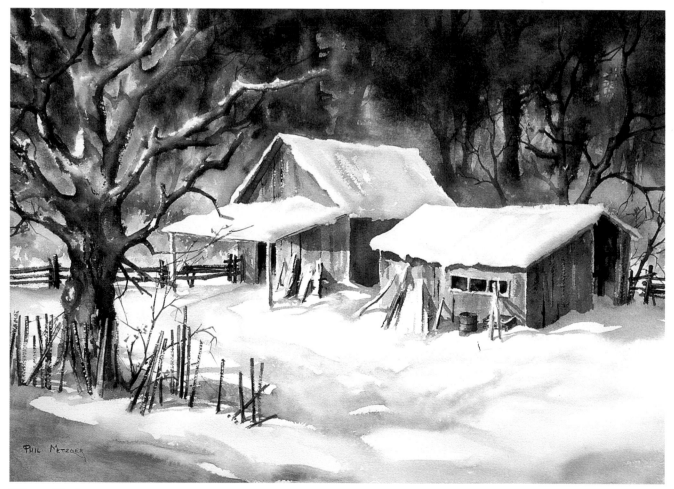

*Winter Sheds*
22″ × 30″ (55.9cm × 76.2cm)
watercolor on Arches 300-lb. (640gsm) cold-press paper

# A Second Look

Many subjects, such as this mill, are full of asymmetries—windows not centered, unusual roof inclines and so on. Such subjects are usually more interesting than proper symmetrical ones. Add some spice to your pictures by deliberately throwing some shapes out of whack.

*The Old Mill*
11"×15" (27.9cm×38.1cm)
watercolor on Arches cold-press paper

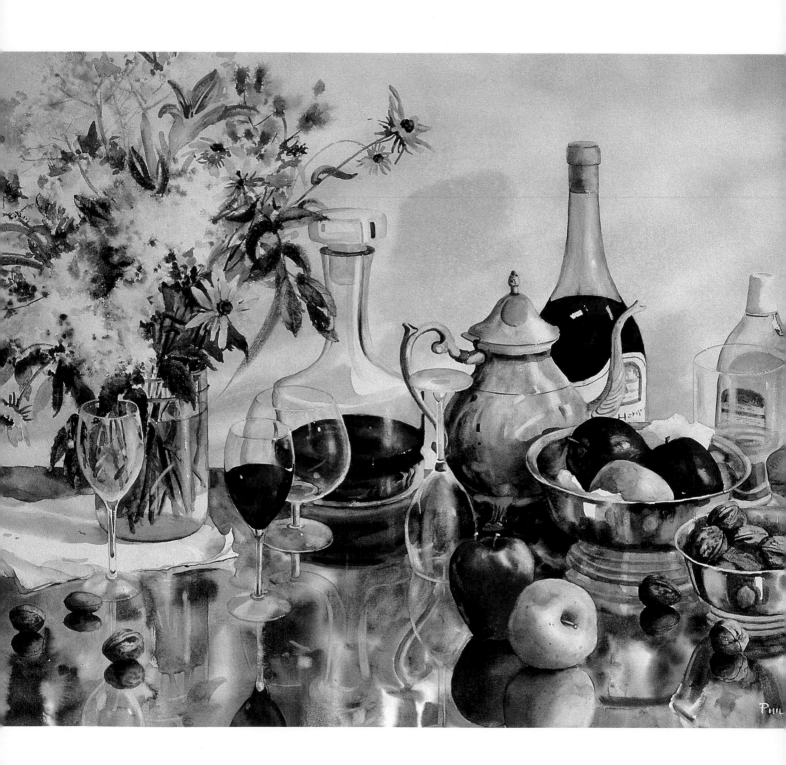

CURVES:
# PUTTING THEM IN PERSPECTIVE

Rectangles fit easily into the rules of linear perspective. They behave well and it's easy to visualize how they'll appear in all kinds of positions. But how do you show curves in perspective? Here's how: Start with something you already know. First draw a rectangle in perspective (the last two chapters show you how) and then draw your curve inside the rectangle. If the rectangle is in perspective the curve within it will also be in perspective.

There are all sorts of curves, of course, but probably the most common one is the circle. In this chapter we'll deal mostly with circles and their close relatives, ellipses.

*Reflections*
34″ × 44″ (86.4cm × 111.8cm)
watercolor on illustration board

# Back to School

In case you've forgotten your high school geometry, here are some reminders:

- A rectangle is a four-sided figure with four right angles. Opposite sides of a rectangle are equal.
- A square is a rectangle with four equal sides.
- A circle is a closed curve, every point of which is equidistant from a point inside the curve (the center).
- A circle's diameter is the longest distance across the circle.
- An ellipse is an oval curved shape.

If you draw a circle inside a square whose sides are the same length as the diameter of the circle, the center of the circle will be the same point as the center of the square. The circle will touch the square at the midpoint of each side of the square—when a curve touches a straight line in this way, we say the curve is tangent to the line.

Now suppose we tilt the square so we're seeing it in perspective. What happens to the circle? It tilts, too, and no longer looks like a circle. It's now an ellipse.

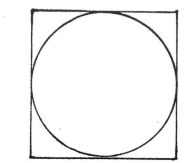

A square is a rectangle with four equal sides. A circle fits neatly inside a square.

center of both circle and square

circle tangent to sides of square

VP

perspective center of square

circle in perspective (an ellipse)

square in perspective

A J.D. Salinger story describes a boy with a head that looked as if it had been squeezed in a carpenter's vise. That's how an ellipse is formed—by squeezing a circle. The more you squeeze, the more flattened the ellipse becomes.

# Rounding the Corners

A common mistake is to draw ellipses with pointy ends. An ellipse, like a circle, is a smooth curve with never any corners.

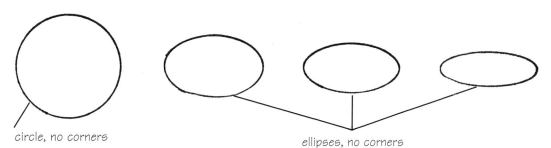

circle, no corners

ellipses, no corners

## More Eye Levels
Suppose you're drawing an ellipse inside a square in perspective, but the eye level is not through the square's center. Although the square may look quite distorted, you still draw the ellipse smoothly inside it, making sure the curve is tangent to all sides of the square.

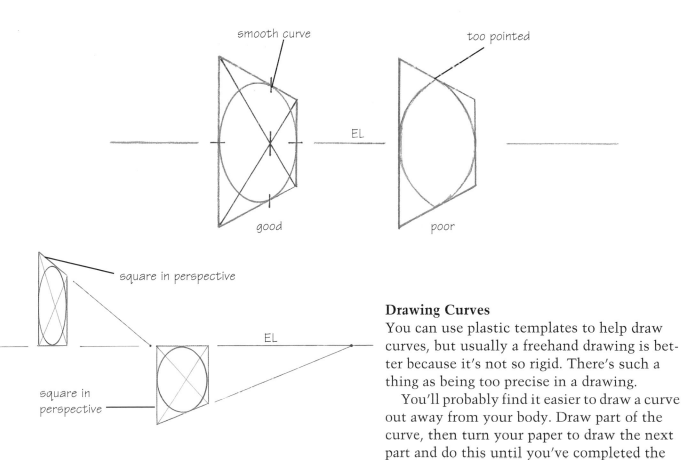

smooth curve

too pointed

EL

good

poor

square in perspective

EL

square in perspective

**Drawing Curves**
You can use plastic templates to help draw curves, but usually a freehand drawing is better because it's not so rigid. There's such a thing as being too precise in a drawing.

You'll probably find it easier to draw a curve out away from your body. Draw part of the curve, then turn your paper to draw the next part and do this until you've completed the curve.

# Cylinders in Perspective

Suppose you're drawing a cylindrical silo or pipe or tunnel in perspective. If the curved ends give you trouble, start by sketching a rectangular shape and then draw the curves inside it.

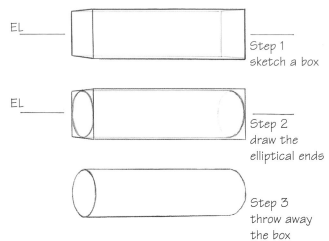

EL

**Step 1**
sketch a box

EL

**Step 2**
draw the elliptical ends

**Step 3**
throw away the box

## *How Eye Level Affects Curves*

What's wrong with the vase on the left (below)? Something seems out of whack. We see the bottom of the vase as a straight line, but the curve at the top suggests we're looking down at the vase. The problem: This picture has two eye levels. That's illegal unless your name is Picasso. To draw or paint a realistic picture choose an eye level (only one!) and stick with it.

EL          EL

EL

EL

wrong          right          right          also right

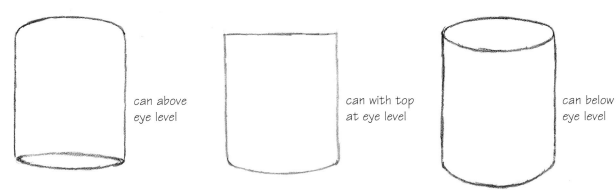

can above
eye level

can with top
at eye level

can below
eye level

Get in the habit of comparing curves. Here are ordinary cans above, at and below eye level. Study the way the curved ends vary according to their distance from the eye level.

## More About Eye Level

Curves become more curvy the farther they are above or below eye level. This is easy to see if you imagine a tall stack of doughnuts. A doughnut straight ahead of you—that is, at your eye level—won't look very curved at all. As you glance up the stack you begin to notice some curvature. At the top of the stack lies the most curved doughnut of all. If the stack were very high and if you could see the bottom of the top doughnut, it would appear circular.

In the same way, doughnuts below your eye level appear more curved the farther down they are.

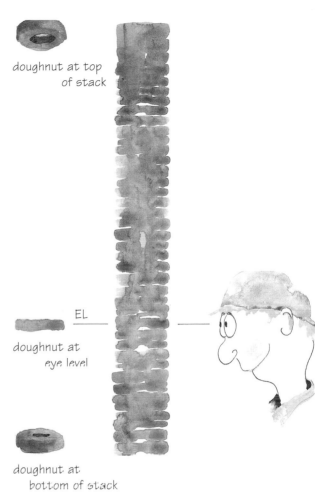

doughnut at top
of stack

EL

doughnut at
eye level

doughnut at
bottom of stack

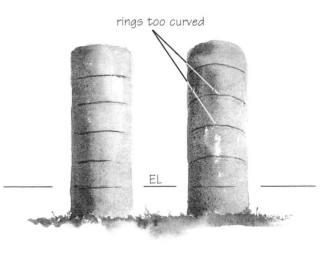

rings too curved

EL

EL

Here's how a round silo might look to an observer down the hill. The silo is above eye level. Its bottom is curved (although you might not actually see it) and the ribbed sections become more curved as they appear higher above eye level.

The silo on the right seems to be falling over backwards. That's because the curves have been drawn improperly. This sort of error happens if you begin drawing the curved rings at the bottom and increase their curvature too much as you go up the silo. By the time you get to the top you have far too much curvature. To avoid this try starting with the topmost curve and work your way down.

# Boxing

No matter what curved object you draw, it may help to stick it in a box. Like drawing through, boxing an object helps you visualize it better. Sometimes you start with a box and draw the object inside it; other times you might draw the object freehand first and only sketch a box around it if the drawing needs fixing.

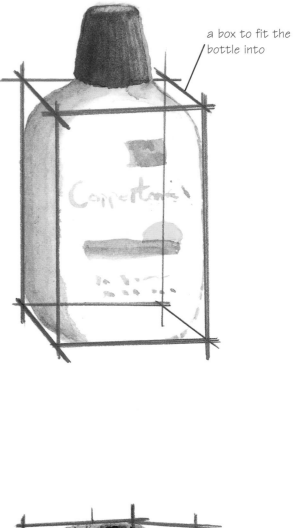

a box to fit the bottle into

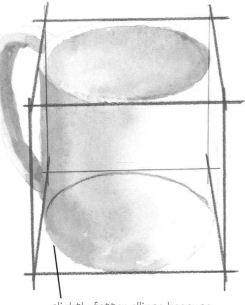

slightly fatter ellipse because it's farther below eye level than top ellipse

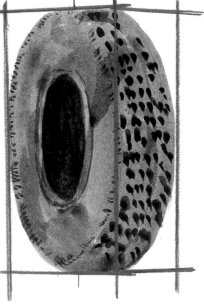

# Foreshortening

Foreshortening is getting an illusion of depth by shortening receding lines. You use foreshortening all the time. If you draw the side of a building shorter than you know it to be (because the side is receding from you), you're using foreshortening. More commonly the term is used when drawing such objects as tree branches or the human figure.

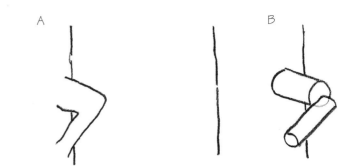

When you draw branches advancing or receding, it's helpful to treat the branches (in fact, the entire tree) as a bunch of cylinders. It may be difficult to "see" the branch coming toward you in A but if you draw the branch as cylinders placed end-to-end the picture becomes clearer B.

The human form (and other animal forms) can be seen as a combination of cylinders. Seeing parts as cylinders helps you understand how the parts are shaped and joined. When you draw rounded objects, do plenty of drawing through. If you are clear about what's around the far side of a curved object your drawing will certainly be more convincing.

Try seeing a tree as a combination of cylinders. This will help make branches go where you want them to. Be especially careful to show the curved lines where a branch meets the trunk. Getting these curves right helps suggest direction.

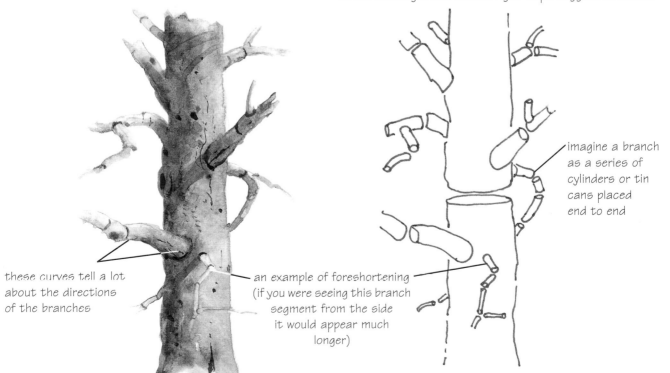

these curves tell a lot about the directions of the branches

an example of foreshortening (if you were seeing this branch segment from the side it would appear much longer)

imagine a branch as a series of cylinders or tin cans placed end to end

# Arches

Besides their use as supports in bridges, tunnels, cathedrals, doors and windows, many arches offer the artist graceful curves that can break the monotony of an otherwise rectangular structure. The curve of an arch may be circular, elliptical, parabolic—in fact, any shape the designer likes.

Drawing an arch in perspective can be tricky, but you can resolve problems using techniques already discussed: drawing through and boxing.

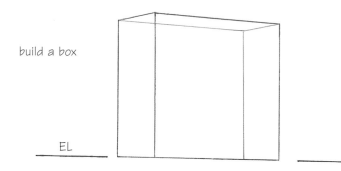

build a box

EL

draw the arch inside the box

throw away the box

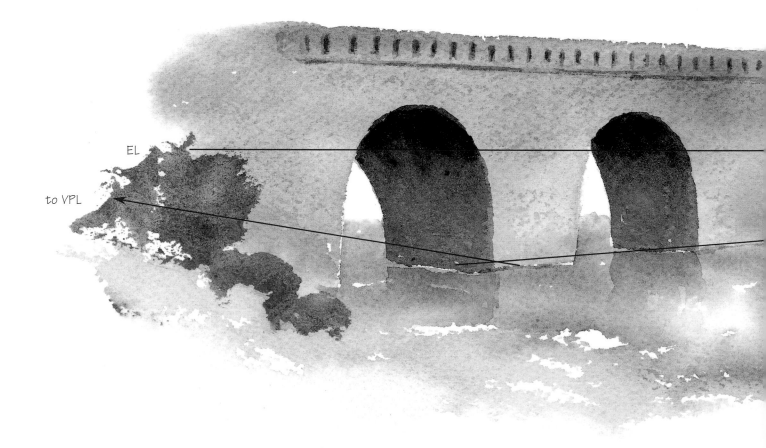

EL

to VPL

Here are some common arch shapes you might encounter. In addition to using the techniques of drawing through and boxing, do plenty of size estimation using the thumb-and-pencil technique. Check the height of the arch versus its width, for instance, or the distances between arches.

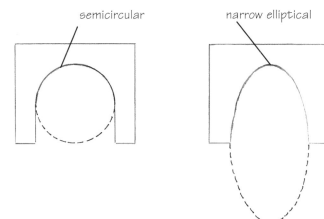

semicircular

narrow elliptical

broad elliptical

Here's an example of an arched bridge. The bridge would cast shadows onto the water's surface, but I left them out to keep the picture simple.

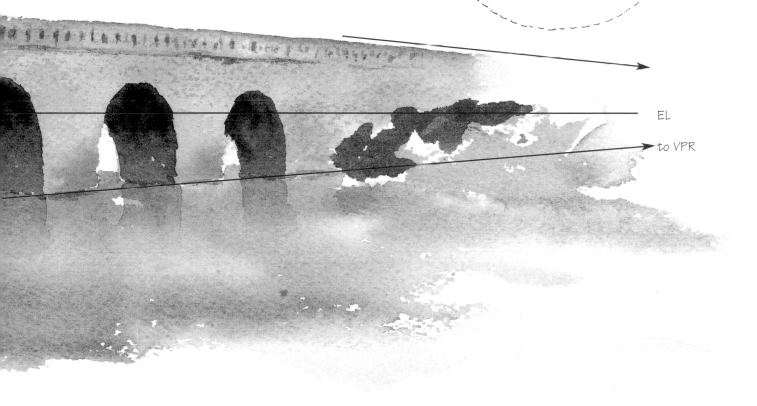

EL

to VPR

# When You Want Symmetry

Drawing a simple object, such as a bottle, with perfect symmetry can be daunting. Most of us have a built-in bias that makes us draw things a little lopsided. If you're sketching someone's head, for instance, you might tend to make one eye higher than the other. Here are a couple of ways to check yourself and get symmetry when you want it. (By the way, don't be a slave to symmetry. The guy you're sketching may very well have one eye higher than the other!)

## Use a Mirror

When you see an object in a mirror you see everything right-left reversed. If you look at your drawing in a mirror you'll instantly spot asymmetries and other things out of whack that you thought were perfect.

Make a small mirror a part of your painting and drawing tools and have it with you when you work outdoors. In the studio, if you have the space it's helpful to mount a large mirror on the wall behind you. When you want to see your picture in reverse, step aside and see it in the mirror.

## Use Tracing Paper

Let's say you're drawing a rounded bowl and having a heck of a time getting it symmetrical. (You thought it was symmetrical until you saw it in a mirror!) Here's a way to get it right. Draw a vertical line dividing the bowl in half. Lay a piece of tracing paper over the drawing and trace over one half. Flop the paper over the other half and you'll see where the two halves fail to match.

You may not *want* things symmetrical, of course. A lot of the charm of Michael Brown's work, for example, lies in his use of asymmetrical objects. There are plenty of examples in his book, *Realistic Collage, Step by Step*, North Light Books.

tracing paper

lopsided bowl

trace over one half of the bowl

tracing paper flipped over

now you can see where the right side doesn't match the left

**Mirror, mirror . . .**
I guarantee you, a cheap mirror will be one of your best investments. I'm always amazed at how different my developing picture looks when reversed in a mirror.

# A Second Look

A realistic picture such as this won't be believable if you don't get the curves right. I spent a lot of time relating curves to one another and relied on the use of a mirror to help out.

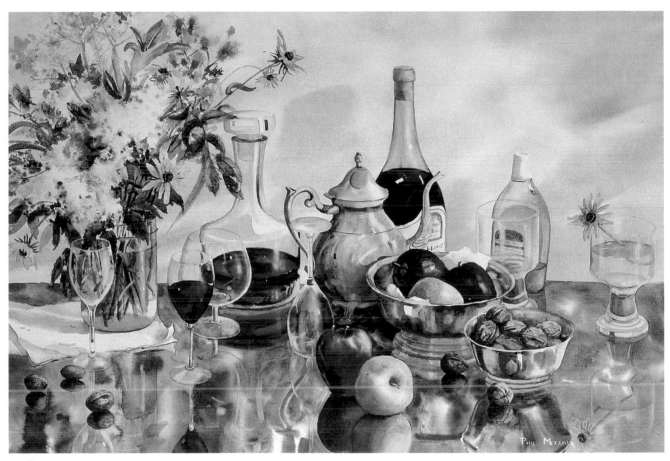

*Reflections*
34" × 44" (86.4cm × 111.8cm)
watercolor on illustration board

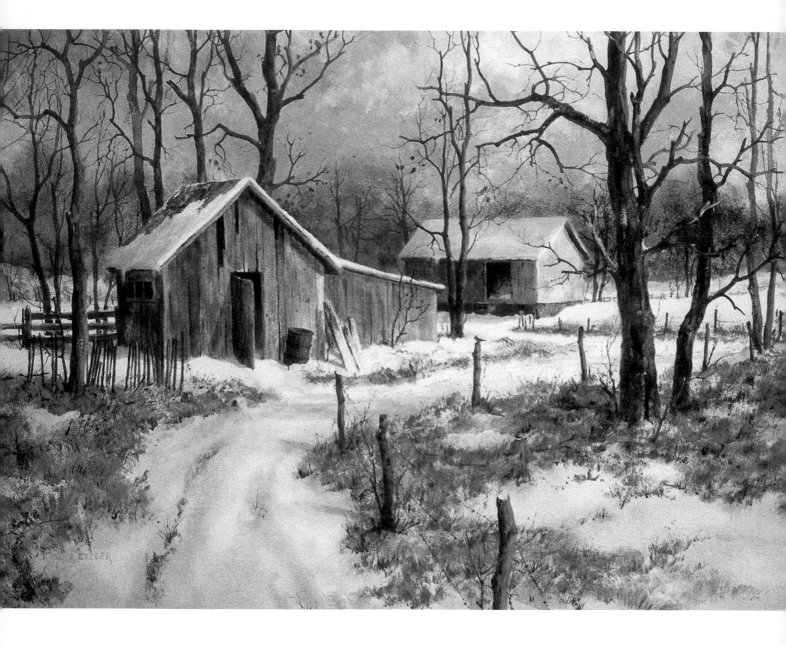

PERSPECTIVE:
# SPECIAL PROBLEMS

Sometimes the solution to a perspective prob-
lem is not as obvious as those we've already
discussed. You can get involved in structures that
arc not simple rectangular shapes, for example, or
lines that wander on their way to vanishing points.
In this chapter we'll explore briefly a selection of
special situations:
- inclincs
- stairs
- roads, paths, streets
- fields and streams
- tile floors

*Cardinal*
18" × 24" (45.7cm × 61cm)
watercolor and acrylic on illustration board
Collection of Mr. and Mrs. Richard Sherrick,
Rockville, Maryland

# Inclines

## *Cheese Wedge*

To draw an incline (or a ramp) in perspective, first draw a box in perspective and then slice it in two diagonally as shown. What you have then are two wedges in perspective. The bottom wedge looks the way a ramp would in perspective.

## *Building a Ramp*

Adding a ramp to a sidewalk is easy. Simply add a box drawn in the same perspective as the sidewalk and then slice the box in half. That's all there is to it! If you've ever poured concrete, you can see how you might actually build a box like the one sketched and half fill it with concrete on a slope.

first draw a block
in perspective

slice it diagonally

and you're left with an
incline in perspective

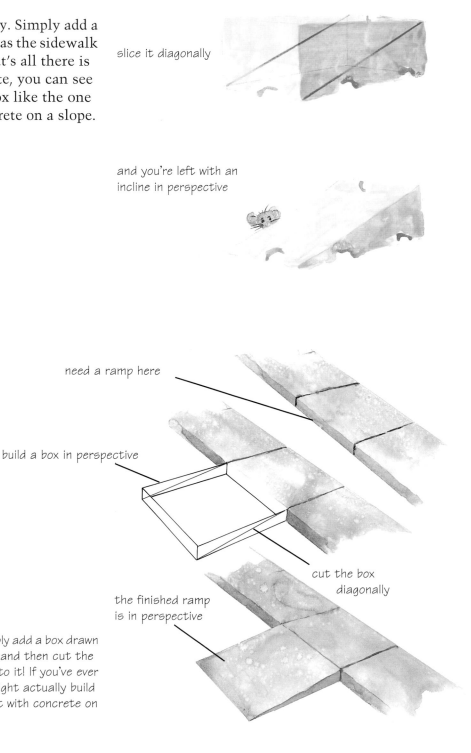

need a ramp here

build a box in perspective

cut the box
diagonally

the finished ramp
is in perspective

Adding a ramp to a sidewalk is easy. Simply add a box drawn in the same perspective as the sidewalk and then cut the box diagonally in half. That's all there is to it! If you've ever poured concrete, you can see how you might actually build a box like the one sketched and half-fill it with concrete on a slope.

# Stairs

If you think of stairs as combinations of rectangular boxes, you're well on your way to drawing them correctly. (If you're confronted with weird stairs—circular, for instance—you'll need either a good cyc or advanced architectural drawing beyond the scope of this book.) Study these illustrations to get an idea how to approach a stairway.

Treat a stairway as a wedge or ramp. Then think of each step as a rectangular box whose receding lines, as usual, aim for vanishing points on the eye level. You don't have to do all the construction shown in these steps, of course; just draw what you see and use construction lines to help figure out what, if anything, looks wrong.

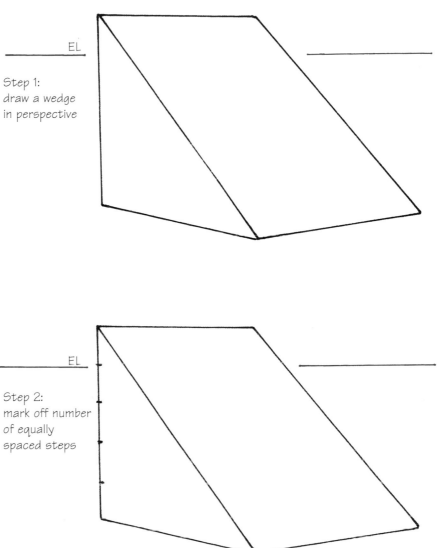

EL

Step 1:
draw a wedge
in perspective

EL

Step 2:
mark off number
of equally
spaced steps

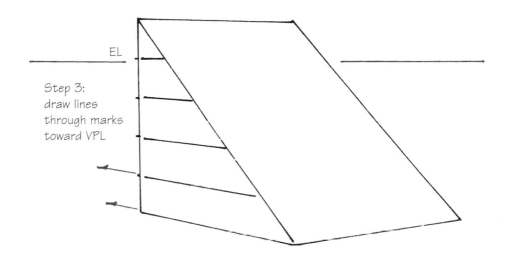

EL

Step 3:
draw lines
through marks
toward VPL

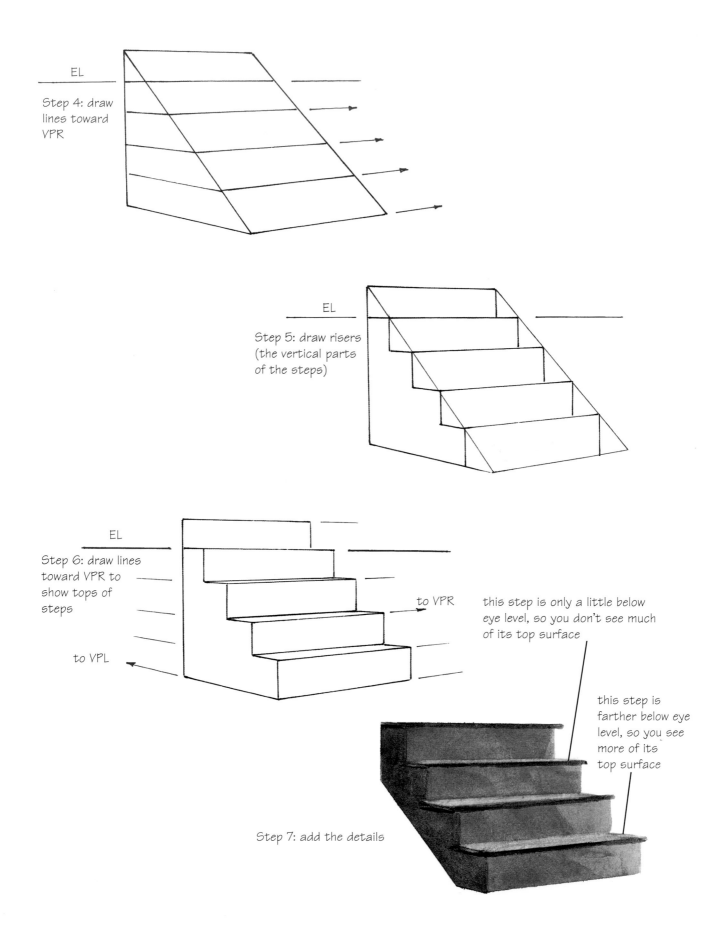

EL

Step 4: draw lines toward VPR

EL

Step 5: draw risers (the vertical parts of the steps)

EL

Step 6: draw lines toward VPR to show tops of steps

to VPR

to VPL

this step is only a little below eye level, so you don't see much of its top surface

this step is farther below eye level, so you see more of its top surface

Step 7: add the details

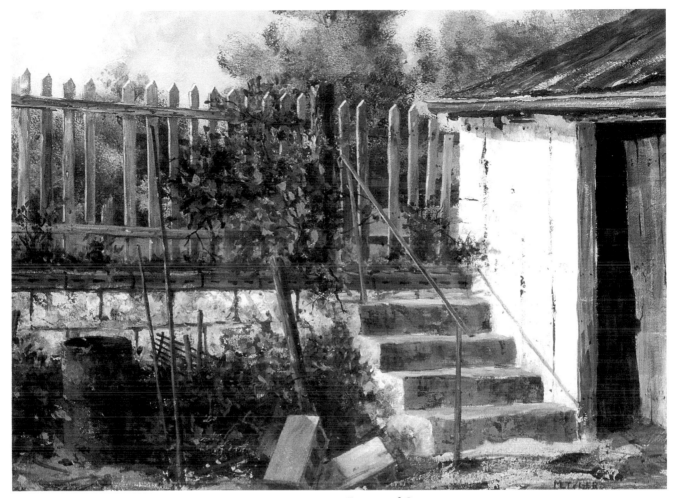

Things are a bit askew in this corner of an old farmyard, but basic linear perspective still holds. The steps are similar to those in the accompanying exercise.

*Farmyard Steps*
22" × 30" (55.9cm × 76.2cm)
watercolor on illustration board

# Paths, Roads, Streets

## Steep and Flat Roads

Suppose you have a road or street or path receding from the foreground toward a house in the distance. If the land leading to the house is relatively flat, you can suggest that by making the road wide in the foreground and narrow in the distance. If, on the other hand, you want to show the road leading up a hill toward the house, keep the sides of the road more nearly parallel.

In either case, you have to try various widths to find what feels right. If, for example, you widen the road too much in the foreground it may not look convincing—it may feel like a four-lane highway. But if you make the sides of the road too nearly parallel the result will be equally unconvincing—the road may look vertical!

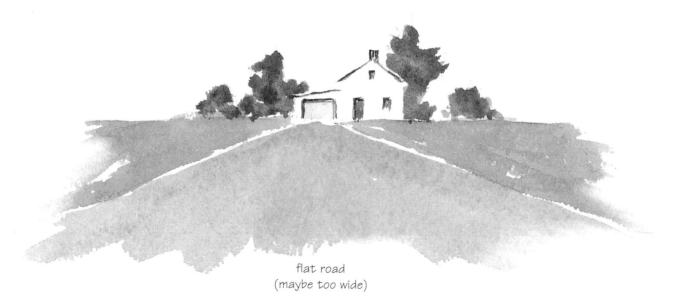

steep road
(probably too steep)

flat road
(maybe too wide)

## Zigzagging Road

In many landscapes a road or path helps lead the viewer's eye toward the center of interest in the picture. A straight road may do this in too obvious a manner (you might as well put a sign in the painting saying "this way to center of interest"). Often a more suitable solution is to use a zigzagging road or path that leads to the center of interest in a more entertaining and less obvious manner.

## Country Road, Hilly Terrain

Here's a way to suggest distance over rolling or hilly terrain. The road is like a roller coaster with a number of dips. Instead of smoothly narrowing as it goes into the distance, the road seems to narrow abruptly because the connecting parts of the road are down in a dip and lost to the viewer's sight.

zigzagging road, more interesting than a straight one

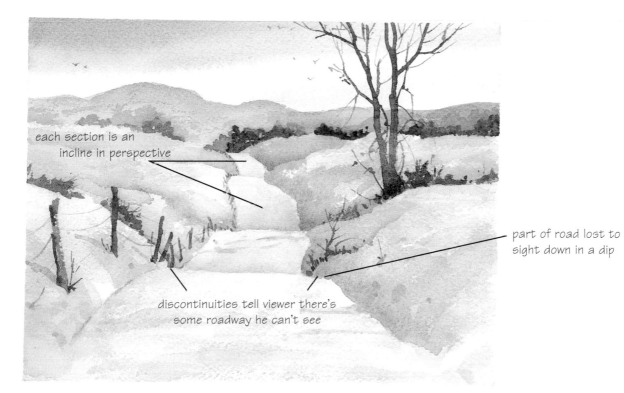

each section is an incline in perspective

part of road lost to sight down in a dip

discontinuities tell viewer there's some roadway he can't see

# Fields and Streams

## Plowed Fields

Sometimes plowed, furrowed fields fit well in a farm scene. You can arrange the furrows so they help lead the eye into the distance, but be careful not to make the arrangement too rigid and obvious. The same is true of all the perspective techniques—try to use them so they *quietly* lead the eye into the distance.

Plowed fields

## Streams

Like a road or path, the wanderings of a stream can help give a feeling of distance and at the same time tell the viewer something about the contours of the land. The way you treat the surface of the stream affects the mood of the picture; a turbulent surface gives you an active picture and a smoother surface gives you a quieter picture.

angled lines suggest movement, turbulence

horizontal lines suggest flat, quiet water

# Tile Floors

There are many places in architecture where it's helpful to show patterns, and the tiles in a floor are one example. They can be drawn convincingly using the principles of linear perspective. This example employs one-point perspective. The vanishing point is straight ahead, on the eye level. (You can use the same method to figure out tiles in a two-point perspective situation.)

First mark off equal spaces along the line where floor and wall meet. The spaces represent the widths of tiles. Now draw lines from the vanishing point through each of those markings. The result is a series of rows of tiles (at this stage they look like floorboards).

Next, draw two horizontal lines to mark off one of the tiles. You can estimate where to draw these lines—try until you have a single tile that feels okay. Since we're using one-point perspective, the lines marking off individual tiles should all be horizontal and parallel to one another. (In two-point perspective, they would be neither horizontal nor parallel.)

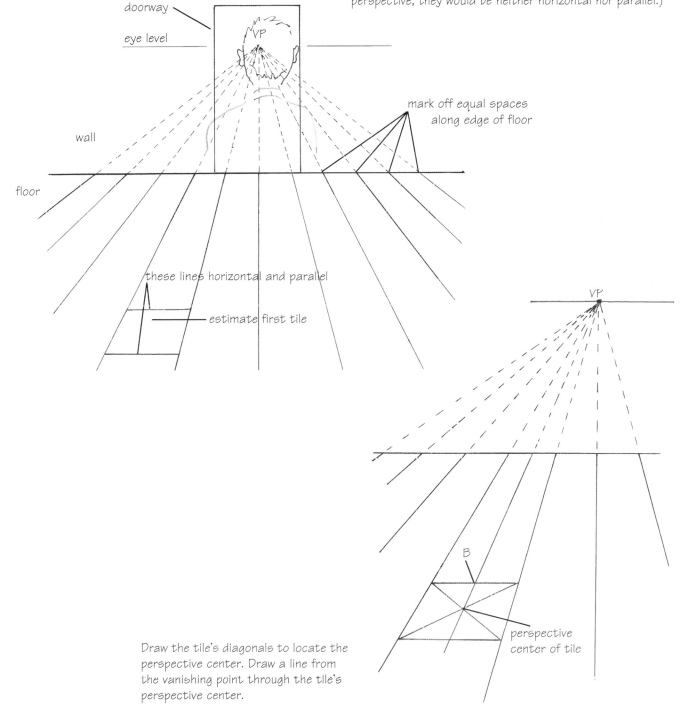

Draw the tile's diagonals to locate the perspective center. Draw a line from the vanishing point through the tile's perspective center.

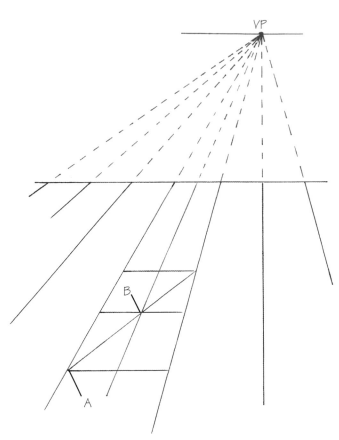

Draw a line from point A through point B. Then draw the edge of the next tile as shown.

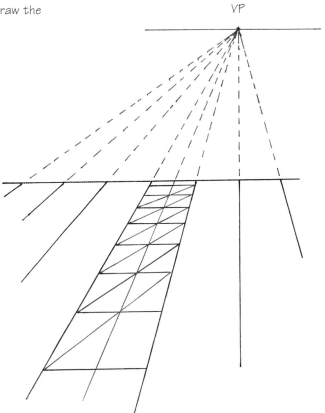

Continue in the same manner until all the tiles in the row are complete. Now you can extend horizontal lines in both directions to complete the floor.

# A Second Look

*Cardinal* employs all the perspective techniques discussed in this book.

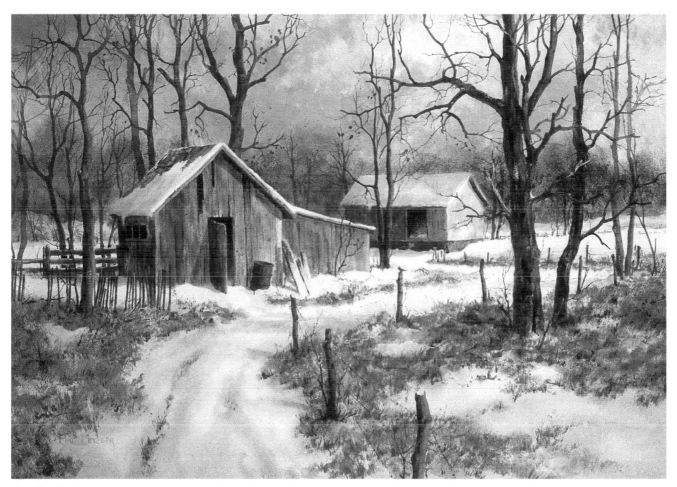

*Cardinal*
18" × 24" (45.7cm × 61cm)
watercolor and acrylic on illustration board
Collection of Mr. and Mrs. Richard Sherrick,
Rockville, Maryland

# BIBLIOGRAPHY

Albert, Greg, and Rachel Wolf
*Basic Drawing Techniques*
Cincinnati: North Light Books, 1991
An excellent starter book for all kinds of drawings.

Brown, Michael David, and Phil Metzger
*Realistic Collage, Step by Step*
Cincinnati: North Light Books, 1998
Michael Brown's beautiful collages demonstrate the effective use of perspective techniques. In many examples, Brown also shows how you may effectively *ignore* the traditional rules of perspective.

Dodson, Bert
*Keys to Drawing*
Cincinnati: North Light Books, 1985
For both beginner and intermediate artists; has a good chapter on perspective.

Metzger, Phil
*Enliven Your Paintings With Light*
Cincinnati: North Light Books, 1993
Includes a lot about shadows and the effects of light on perspective.

Metzger, Phil
*Perspective Without Pain*
Cincinnati: North Light Books, 1992
Covers much of the same ground as the book you are holding, but also includes work exercises and some advanced problems. Black and white.

Petrie, Ferdinand
*Drawing Landscapes in Pencil*
New York: Watson-Guptill, 1979
If you like pencil drawings, you'll love the work in this book. Includes some treatment of perspective.

Pike, John
*Watercolor*
New York: Watson-Guptill, 1966
There are lots of fine watercolor books—this is my favorite.

# INDEX